THE WHERE, THE WHY, AND THE HOW

THE WHERE
THE WHY
AND THE HOW

75 ARTISTS ILLUSTRATE WONDROUS MYSTERIES *of* SCIENCE

FOREWORD BY
DAVID MACAULAY

BY
JENNY VOLVOVSKI,
JULIA ROTHMAN,
and **MATT LAMOTHE**

CHRONICLE BOOKS
SAN FRANCISCO

Library of Congress Cataloging-in-
Publication Data available.

ISBN 978-1-4521-0822-3

Manufactured in China

Science coordinator Margaret Smith
Design by ALSO

The text face is Mercury Text,
designed by Hoefler & Frere-Jones.
The titling face is Verne Jules,
designed by Isaac Tobin.

Quote from Richard Feynman (facing page) is
from a BBC interview conducted in 1981.

10 9 8 7 6 5

Chronicle Books LLC
680 Second Street
San Francisco, CA 94107
www.chroniclebooks.com

"But I don't have to know an answer.
I don't feel frightened by not knowing
things, by being lost in the mysterious
universe without having any purpose—
which is the way it really is, as far as
I can tell. It doesn't frighten me."

—RICHARD FEYNMAN

CONTENTS

Canaletto was a Venetian painter and print maker of the seventeenth century. Like many of his contemporaries, he often used a device called a camera obscura to help create images of great detail. The camera obscura was a darkened space—a room, tent, or wooden box—with a small hole in one side. Light reflected off the desired scene passed through the hole and was projected upside down onto the opposite wall or surface.

As shown below, this centuries old optical phenomenon could be very useful even in less artistic pursuits.

[1] Spherical eggs would roll away. The asymmetrical, oval-shaped eggs roll in a circle, decreasing the chance of having them get lost or roll out of a nest. They also pack tightly in a nest to better keep each other warm.

INTRODUCTION

Today we're spoiled with an abundance of information. We carry devices that fit in our pockets but contain the entirety of human knowledge. If you want to know anything, just Google it.

Driving in the car recently, the topic of conversation somehow steered to the question of why eggs are shaped like eggs. We all argued for a few minutes, each of us yelling over the other, about whether the shape has an evolutionary purpose. It only took a few minutes for someone to bring up Wikipedia on their phone and quickly dispel the mystery. The answer[1] was read aloud to a hushed backseat. It was fascinating.

While we all learned something new, as soon as the answer was read, the discussion quickly quieted down. We all gave nods of agreement and the conversation moved on. The most fun, the period of wonder and funny guesses, was lost as soon as the 3G network kicked in.

Fortunately, there are still mysteries that can't be entirely explained in a few mouse clicks. With this book, we wanted to bring back a sense of the unknown that has been lost in the age of information. While scientists have figured out a great deal, much remains theoretical, and sometimes multiple opposing theories exist. We've gathered together over 50 scientists from anthropologists to physicists, people studying viruses and others investigating the earth's core. These scientists graciously agreed to be part of the project, and to explain the theories behind some of these unanswered questions.

Much of the inspiration for this book came from looking through old scientific charts and diagrams, in periods where the scientific world was still very much in early development. There are incredibly beautiful anatomically incorrect drawings from the Japanese Edo period, and wonderful classroom diagrams from the 1950s detailing the structure of blood cells. These visually unique works attempt to impart an understanding of a phenomenon in nature.

We invited 75 artists to make their own scientific illustrations or charts based on the questions posed by the scientists. Since these are all still mysteries, the artists could make their own explorations of the topic. We chose a mix of well-known and up-and-coming illustrators, comic artists, fine artists, and designers who we felt would be good at making informational artwork. After perusing their portfolios we matched the artist to the scientific question, trying to give each artist the question that matched best with their work, whether it required drawing dark matter or purring cats.

We hope by reading this book, you'll learn some interesting things, but also enjoy reflecting on the mysteries themselves. Remember that before you do a quick online search for the purpose of the horned owl's horns, you should give yourself some time to wonder.

WRITTEN BY / JENNY VOLVOVSKI,
JULIA ROTHMAN,
and MATT LAMOTHE

WHAT EXISTED BEFORE THE BIG BANG?

T IS SURPRISING, BUT TO CALL the beginning of the universe the "Big Bang," current science's shorthand name for that most distant past moment to which one can still trace the operation of our laws of physics, is a bit of a misnomer. Current evidence suggests that, far from being "big," the whole vast expanse of space and all the visible galaxies and stars originated in a dense sphere of glowing gas much smaller than a pea. Some cosmologists, affecting a familiarity with events so far removed from our everyday experience, refer to the beginning now as just the "Bang." General relativists, scientists who study physical consequences of Einstein's 1916 theory of relativity, chalk in hand, draw a horizontal line at the base of their blackboards and say: This is the singularity where it all started.

The era of the universe we now live in began about 14 billion years ago, when all that we can see today was compressed to a very high density and pressure, a plasma hotter than that in the core of a star. The observed elemental composition of the universe, especially the amount of helium present in it, is our best evidence for the first few seconds of the universe's existence.

Another sign of the first fractions of a second of time after a "beginning" is the smoothness and uniformity of microwaves that fill the cosmos. The rules of Einstein's theory of general relativity deeply interconnect space and time to mass and energy. Matter can, in a sense, create the space it expands into and generate the time in which to do it. The universe was born in a state of very low entropy, which gives time its forward arrow and its enormous impetus to evolve. To see this, picture an alternative universe born into a state of high entropy—imagine the universe as a lukewarm, uniform gas, evenly spread throughout a large box. Viewed day after day, the gas molecules in the box would be seen to bounce around, but the overall picture of a uniform gas in a box would remain unchanged, with no evolution of the overall temperature or distribution of the gas anywhere in the box. A low entropy state, on the other hand, is like a box which is empty (a vacuum) except for a concentrated ball of hot gas in one corner. This situation is not stable, and the ball of hot gas will expand quickly to fill the entire volume of the box, cooling as it goes. The analogy to the Big Bang early universe is similar, except that there is no "empty box" when the universe starts to expand—instead the mass-energy of the universe creates the space-time to expand into, as it evolves.

Was there an era before our own, out of which our current universe was born? Do the laws of physics, the dimensions of space-time, the strengths and types and asymmetries of nature's forces and particles, and the potential for life have to be as we observe them, or is there a branching multi-verse of earlier and later epochs filled with unimaginably exotic realms? We do not know.

12

WRITTEN BY
BRIAN YANNY PhD
Research Scientist
Fermi National Accelerator Laboratory

ILLUSTRATED BY
JOSH COCHRAN
www.joshcochran.net

WHAT IS DARK MATTER?

ASTRONOMERS CAN MAKE estimates of galaxy masses in many different ways. We can calculate how much mass explains the light from galaxies seen in telescopes. We can also measure the speeds of stars on the outer edges of galaxies. The faster these stars move, the more gravitational pull from the galaxy is necessary to keep the stars from escaping.

Unfortunately, these two measurements lead to different galaxy masses. The stars at a galaxy's edge are moving so fast that the mass of luminous stars and gas alone cannot explain why the stars are still a part of the galaxy at all. Thanks to careful observations, we now know that dust, planets, and black holes cannot fully explain the presence of these fast-moving stars. To explain the gravity that keeps these stars in the galaxy, we theorize that there must be more mass, dark matter, that keeps the stars bound to the galaxies.

Light from the early universe reveals that dark matter must be completely different kinds of particles from the ones that make up us, the earth, and the sun. Could dark matter be an exotic new particle? The contrast in scales is thrilling: The vast majority of the enormous mass of the universe might be explained by yet-undetected, infinitesimal subatomic particles. Satellites, tabletop experiments, and linear colliders are searching now for the dark matter particle.

WRITTEN BY
KATIE RICHARDSON
PhD candidate
University of New Mexico

ILLUSTRATED BY
BETSY WALTON
www.morningcraft.com

WHAT IS DARK ENERGY?

N 1998, ASTROPHYSICISTS WERE shocked when new data from supernovae revealed that the universe is not only expanding, but expanding at an accelerating rate. Until then, it was widely believed that the rate of expansion was slowing due to the gravitational attraction of ordinary and dark matter in the universe. To explain the observed acceleration, a component with strong negative pressure was added to the cosmological equation of state and called "dark energy."

A recent survey of more than 200,000 galaxies appears to confirm the existence of this mysterious energy. Although it is estimated that about 73 percent of the universe is made up of dark energy, the exact physics behind it remains unknown. The simplest explanation, called the "cosmological constant," is that dark energy is the intrinsic, fundamental energy of a volume of space, filling it homogeneously. Other models, like "quintessence," propose that dark energy is more dynamic and can vary in time and space. Common to both models, however, are the assumptions that dark energy is not very dense and interacts only with gravity—two properties that make it extremely difficult to detect in the laboratory.

WRITTEN BY
MICHAEL LEYTON PhD
Research Fellow
CERN

ILLUSTRATED BY
BEN FINER
www. benfiner.com

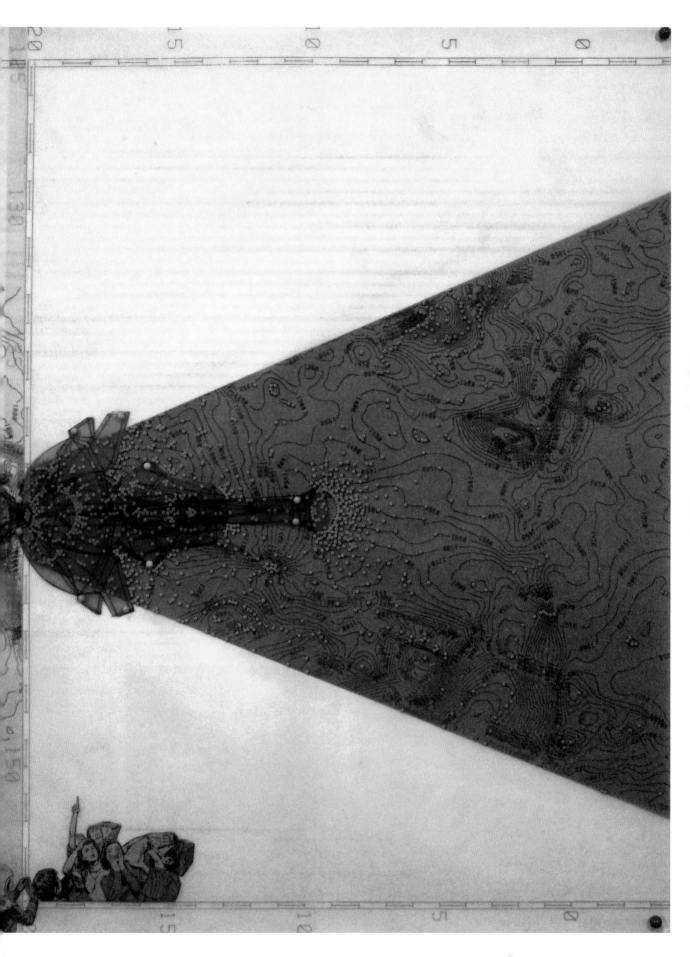

HOW DOES GRAVITY WORK?

I N THE 1600S, GRAVITY WAS as simple as an apple falling on Isaac Newton's head. Newton's laws defining the behavior of gravity were a perfectly good explanation within the confines of the earth. Using the ideas of absolute space, and a simple law for how gravity changed with distance from the massive object, he found a way to extend the analysis to the heavens. His laws successfully predicted the motion of the planets and other bodies, but we discovered problems with his ideas as we learned more about our solar system. One annoying deviation in Mercury's orbit around the sun, for example, hung about the neck of physicists. It wasn't until Einstein developed the theory of general relativity in 1916 that this mysterious, previously unpredicted motion was resolved. Even though the discrepancy itself was very small, the solution that was proposed was a radical departure from Newton's ideas about gravity: Space itself had to be curved in response to the presence of matter. This curvature meant that the properties of the very fabric of our universe had to be rethought.

Moreover, the story is not finished. We know that general relativity is not the final answer, because we have not been able to synthesize gravity with the other known laws of physics in a comprehensive "theory of everything." Several relatively new concepts like dark matter and dark energy, which are used to explain the expansion of the universe, plus the quite unexpected way that stars seem to revolve around the centers of galaxies, may all point to another necessary revision to our initial understanding of the simple idea of an apple falling from a tree.

WRITTEN BY
TERRY MATILSKY PhD
Professor of Physics and Astronomy
Rutgers University

ILLUSTRATED BY
THE HEADS OF STATE
www.theheadsofstate.com

CAN ANYTHING ESCAPE A BLACK HOLE?

HEN A MASS AS LARGE as the sun is compressed into a ball a few kilometers in diameter, it becomes an object with such strong gravity that anything that falls inside its critical radius can never escape. This is a black hole. Einstein's classical theory of general relativity predicted the existence of this phenomenon, and Subrahmanyan Chandrasekhar further developed the idea in the 1930s. Einstein's theory, however, doesn't take into account quantum mechanics, a newer theory that finds that every black hole must emit faint radiation, like an extremely dim star. According to this theory, this so-called Hawking radiation leads to the creation of pairs of particles near the surface of the black hole, one just inside, and one just outside the event horizon. The particle on the outside can indeed escape the black hole, even as its partner falls back in. Paradoxically, movement of these particles reduces the mass of the black hole, which then shrinks slightly and becomes hotter. Over trillions of years, this cascade of particles eventually evaporates the black hole entirely. So, the current theory is that if you wait long enough everything escapes!

WRITTEN BY
BRIAN YANNY PhD
Research Scientist
Fermi National Accelerator Laboratory

ILLUSTRATED BY
EVAH FAN & BRENDAN MONROE
www.potatohavetoes.com
www.brendanmonroe.com

WHAT IS THE "GOD PARTICLE"?

THE HIGGS BOSON, SOMEtimes also called by its more complete name the Higgs-Brout-Englert boson, is a hypothetical massive elementary particle predicted to exist in the Standard Model of particle physics. The Standard Model is the best theory we have to date in particle physics that describes the interactions between elementary particles. However, the problem with the Standard Model (without a Higgs field) is that, in order for it to work, all elementary particles would have to be massless. Since we know that particles have mass, we know that the Standard Model without an additional mechanism to give mass to particles is incomplete. Hence, the Higgs field is the name we give to the field which does the job of imparting mass to particles. And, since a field cannot exist without a matching particle, that gives us the Higgs boson. The Higgs boson, and particularly its associated Higgs field, are the as-of-yet undiscovered things which will allow us to explain how particles acquire mass. Mass is what gives our universe substance. We know that interactions occur in nature through the exchange of particles; for example, particles called photons mediate the electromagnetic force, very familiar to

us in everyday life. The so-called W and Z bosons mediate the weak force that is responsible for the radioactive decay of the nuclei in atoms. While the photon has no mass at all, the W and Z bosons are very massive for elementary particles: they are almost 100 times more massive than a proton. This difference in mass is one of the most fundamental problems in particle physics, and the existence of the Higgs boson can solve this puzzle. However, so far the Higgs boson has evaded experimental detection, although we know that it must be heavier than about 120 protons.

The search for the Higgs particle, postulated more than 45 years ago, has been the quest for the Holy Grail in particle physics. Several experiments may have come close to seeing a first glimpse of the particle, but all hope is now on the new experiments at the Large Hadron Collider (LHC) at CERN, in Geneva, Switzerland. This gargantuan circular machine, a ring 27 km long located 100 m underground, smashes two beams of protons, accelerated to the highest energies that can be achieved so far, head-on. These violent collisions transform the energy of the colliding protons into mass, as Einstein's famous formula explains, and can thus create new heavy particles such as the Higgs

boson. The LHC started producing collisions in 2010, and the analysis of these collisions in two large experiments, called ATLAS and CMS, is expected to give the ultimate answer on the existence of the Higgs boson. The search for the Higgs boson may, however, take several years of careful analysis of the billions of collisions that are collected by these experiments.

Confirming the existence of the Higgs boson, the last missing piece in the Standard Model, will be a triumph for science, allowing us to understand the diversity of the particles we know, and the Higgs boson is therefore sometimes also dubbed the "god particle" on the assumption that it will allow us to understand the entire universe. The study of the boson's properties will no doubt also open a door for new questions for scientists.

If the results at the Large Hadron Collider exclude the existence of the Higgs boson, several alternative ideas are already proposed that do not require the existence of the Higgs boson and are generically called Higgsless models. But most particle physicists anticipate that the Higgs boson will be discovered at the Large Hadron Collider in the not too distant future.

WRITTEN BY
ALBERT DE ROECK PhD
CERN Senior Scientist
Part-time Professor at University of Antwerp
Adjunct Professor at University of California, Davis

ILLUSTRATED BY
JORDIN ISIP
www.jordinisip.com

NOTE BENE
Just after this book was written, physicists did indeed find evidence of the Higgs Boson. A triumph for science—congratulations scientists!

WHAT IS ANTIMATTER?

FOR EVERY KNOWN PARTICLE, there exists an associated antiparticle with the same mass and opposite electrical charge. The antiparticle of the electron is the positron, for example, and the proton and antiproton make a similar pair. Matter composed entirely of anti-particles is called "antimatter." In the same way that a proton and an electron form a normal-matter hydrogen atom, an antiproton and a positron form an antihydrogen atom. Antihydrogen atoms are more than hypothetical; nine antihydrogen atoms were created for the first time in 1995 by physicists at CERN. However, these atoms are dif-ficult to study experimentally, because they are quickly annihilated when they come in contact with matter.

There is today no experimental evidence of any significant concentra-tion of antimatter in our observable universe. In other words, the universe we live in consists almost entirely of matter. This phenomenon is puzzling to physicists, given the symmetry between matter and antimatter. Many competing theories attempt to explain how such an asymmetry could have come about. One group of theories focuses on understanding how nature, at the particle level, might favor certain matter reactions in comparison to their antimatter counterparts. Such reac-tions have been observed and studied extensively in the laboratory, but we do not know whether they alone can explain the matter imbalance in the universe. Other theories propose that there are indeed regions of the universe composed primarily of antimatter (a so-called antiuniverse), but that these regions are widely separated from matter-dominated regions or are possi-bly outside of our visible universe. After all, there may be more to the universe than can be seen from Earth!

WRITTEN BY
MICHAEL LEYTON PhD
Research Fellow
CERN

ILLUSTRATED BY
LEIF LOW-BEER
www.leiflow-beer.com

ARE THERE MORE THAN THREE DIMENSIONS?

THE NUMBER OF DIMENSIONS of a space is the number of numbers needed to localize any spot in it. For example, for an ant walking on the floor, we need two numbers to locate it at a given time, in the same way that we humans need two numbers (latitude and longitude) to specify our position on Earth's surface. Surfaces, in general, have two dimensions, and any point's position on them can be determined by two numbers. Those two numbers (which we call coordinates) are referred to a "system of reference" that can be defined in several ways. For instance, we can say that the ant's position in a rectangular room is 4 m from the south wall and 3 m from the west one. The number of dimensions of a space is the same regardless of how we set our system of reference and its coordinates. Since an ant can explore only two dimensions, its world seems to be two dimensional. For a bee flying above the ant, on the other hand, we would need a third number to tell us its height above any point on the floor. Volumes, as well as the space around us, have three dimensions, and we can identify any point in them with three numbers. But, could it be that we are just unable to "see" more than three dimensions, just as the ant can "see" only two?

Consider that when the bee we want to localize is moving, three numbers are not enough to describe its position: we also have to specify at what time it is at a given point. Moreover, when we describe a bee flying in two systems of reference that are relatively moving, say on a train station and inside a train compartment moving away from it, what we call space in one is a mixture of space and time when viewed from the other. The separation we make between space and time is artificial: It is due to the way we choose our system of reference. According to Einstein, our universe is a "spacetime," with four dimensions, length, width, height, and time, and it is curved and changes its form as planets and stars move. Gravity is a manifestation of spacetime's curvature: a massive object, like Earth, deforms spacetime such that other objects around it fall along the curves toward the massive object.

As our universe is examined at an atomic level, physicists expect spacetime to show a very different structure because in the very small scale "tiny ants" and "tiny bees" do not "move" according to Einstein's theory of general relativity, but follow the rules of quantum mechanics, which are completely different. The fact that "quantum bugs" do not move as planets and stars leads us to the question "how do 'tiny bugs' deform spacetime and gravitationally attract other bugs?" There have been different attempts to answer this question. String theory, for example, predicts that there can be 10, 11, or 26 dimensions, depending on the kinds of "bugs" that are wandering around. One intriguing result, which seems to be common in many of the different attempts to explain how spacetime behaves around tiny bugs, is that the number of dimensions of the universe depends on the scale we are using to look at it. In certain situations the universe behaves like it has two and in others like it has four (or even more) dimensions. There are also other weird "spaces" called "fractals" that have been observed in nature, whose structure is the same independent of the scale at which we observe them. Those spaces have non-integer dimensions, that is, we may need 1.58 numbers to localize a spot in a fractal, whatever that means.

Could it be that our universe is fractal? That at very small scales we need only two numbers to tell where a tiny version of you is? Are there really more than four dimensions? So far we have been able to localize any point in our universe with four numbers, but as we perform experiments at smaller scales and at higher energies, who knows what we could find?

WRITTEN BY / ILLUSTRATED BY

HECTOR HERNANDEZ-CORONADO PhD / **TIM GOUGH**
Postdoctoral Researcher / www.timgough.org
Instituto Mexicano del Petroleo

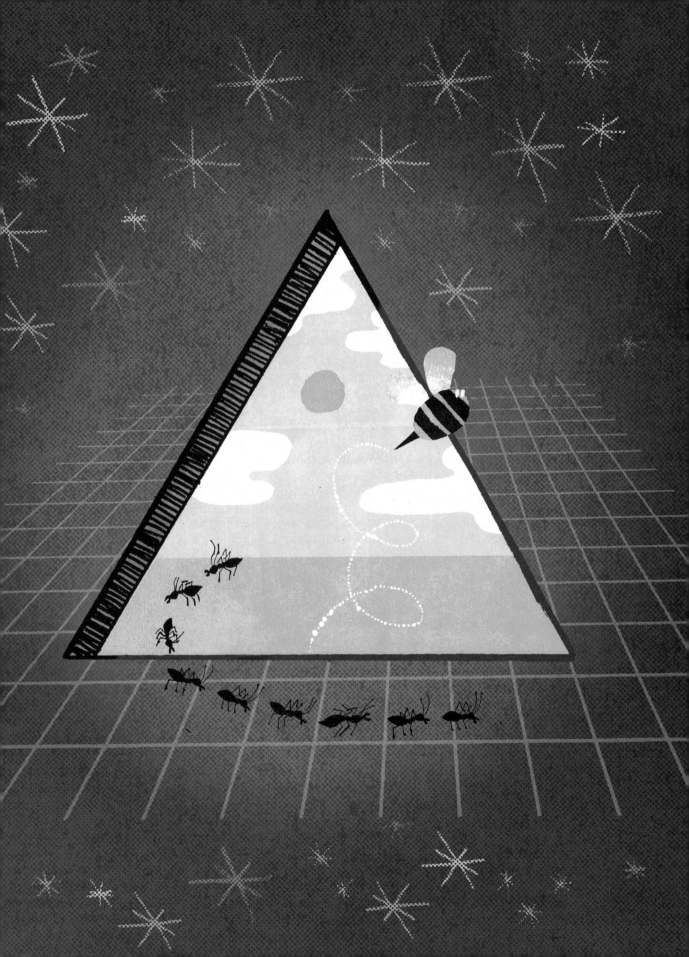

WHAT HAPPENS TO TIME AS YOU APPROACH THE SPEED OF LIGHT?

 UPPOSE YOU GET ON A rocket, strap yourself in, and brace yourself for the launch. Suppose someone on Earth can observe a clock in the rocket. According to Einstein's theory of special relativity, the observer on Earth will see the clock moving slower and slower as you accelerate. You, on the other hand, will not notice any change in the rate time is passing by. Everyone in the rocket will age normally, but the closer to light speed you get, the slower you will age when compared to the people remaining on Earth. If you could see a clock on Earth, it would be moving so fast that you would not be able to see its hands. Once you return to Earth, many years, even decades, may have passed there, while you have aged only a little bit.

One of the many interesting things about time dilation is that it is related to one's motion relative to another body and is also related to how much gravity is acting upon us. For each person— the one on the rocket and the one on Earth—time appears to be passing at the same rate. It is only when we compare the rate of time passage from two or more perspectives (or from different gravitational fields) that the rates are different.

Why is this the case? We don't have an answer. Scientific observations of our perception of reality led us to deduce these rules, but we haven't yet come up with an explanation for the differences in relative passage of time.

WRITTEN BY
HAYM BENAROYA PhD
Professor of Mechanical & Aerospace Engineering
Rutgers University

ILLUSTRATED BY
ANA BENAROYA
www.anabenaroya.com

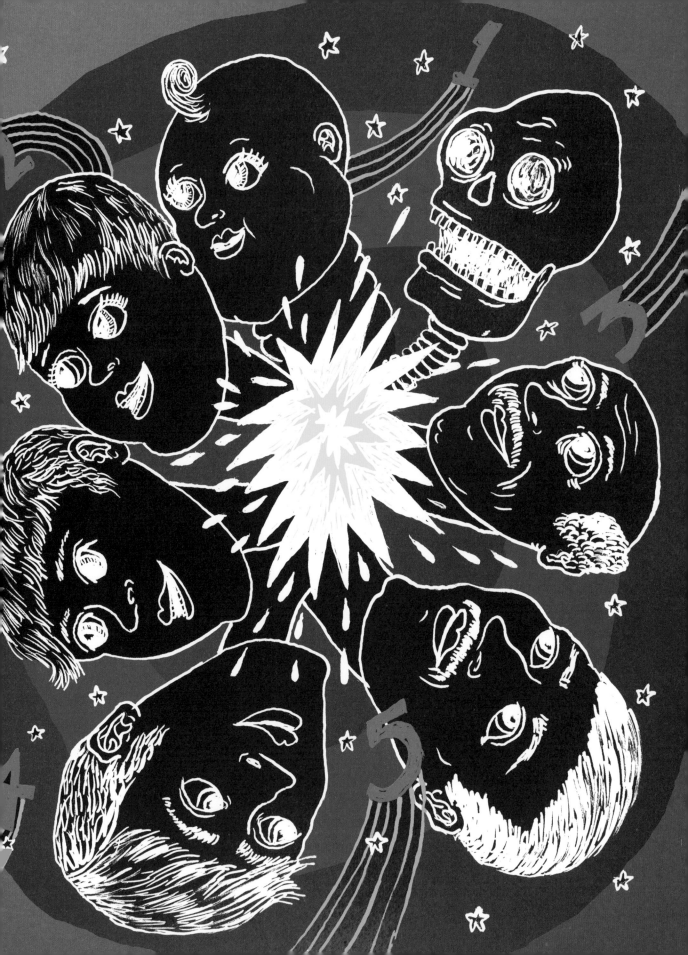

HOW ARE STARS BORN, AND HOW DO THEY DIE?

TARS ARE BORN IN GALAC-tic nurseries of cold, dense, dark gas clouds of molecular hydrogen, carbon mon-oxide, and other simple compounds. Gravity pulls blobs of gas inward until they break off into roughly spherical lumps the size and mass of several solar systems. The center of each lump condenses and heats to the point where the basic nuclear fusion reaction of hydrogen into helium is initiated, creating a central star, while farther out, planet-sized chunks of gas and dust coalesce and orbit the star.

Once the hydrogen of a star's core has been fused nearly entirely into helium (a process that takes 10 billion years for a star with the mass of our sun), the star begins to fuse heavier and heavier elements rapidly until iron is reached, at which point no further nuclear energy can be efficiently extracted. Gravity, which has been held at bay until this point by the central nuclear furnace, then takes over, pulling elements toward the center and crushing the star's core. If the core is less massive than several times the mass of our sun, the star becomes a white dwarf, held together by degeneracy pressure, the same force that keeps electrons separated in their orbits around atomic nuclei. Such a white dwarf will cool off over trillions of years, eventually becoming a black dwarf, a dark lump floating through space, nearly undetectable. On the other hand, if the iron core is very massive, its one-second collapse results in an enormous supernova explosion and a push of core electrons and protons into each other, generating a spinning, pulsing neutron star, or in extreme cases, a new black hole. The neutron star will slow and dim over billions of years, and the black hole will eventually evaporate, again on a timescale many times that of the age of our present universe.

WRITTEN BY
BRIAN YANNY PhD
Research Scientist
Fermi National Accelerator Laboratory

ILLUSTRATED BY
JENNY VOLVOVSKI
www.also-online.com

fig 1

fig 2

fig 3

fig 4

fig 5

fig 6

fig 7

fig 8

fig 9

fig 10

GALACTIC NURSERY

fig 1 nurse gravity

fig 2 baby main sequence star

fig 3 baby red giant star

fig 4 baby white dwarf star

fig 5 baby red dwarf star

fig 6 baby neutron stars

fig 7 baby supergiant star

fig 8 baby black hole

fig 9/10 mobiles

WHAT IS THE ORIGIN OF THE MOON?

UNTIL THE APOLLO LANDINGS in 1969, there were three theories about the origin of the moon: the capture theory, the fission theory, and the double-planet theory. The capture theory supposed that the moon formed elsewhere in the solar system and was captured by Earth's orbit as it traveled by. The fission theory supposed that the moon was spun out of the earth during a period of rapid rotation early in Earth's history. The double-planet theory supposed that the earth and the moon formed simultaneously from small proto-planets, or planetesimals.

When the Apollo astronauts brought back lunar samples for analysis, we discovered that the lunar basalts were nearly identical in composition to Earth's basalts and that its oxygen isotope ratios were identical. The major differences were in some rare-earth element abundances, the moon's near total lack of water and volatile compounds, and the moon's lack of a liquid iron core. By 1984, these data from the Apollo missions formed a fourth theory, the collision theory, which is used in earth science textbooks today to describe the moon's origin. The collision theory posits that during the tumultuous early days of the solar system, a large proto-planet, approximately the size of Mars, collided with the early Earth, which had already stratified into a core, mantle, and crust. The resulting impact remelted the earth's crust and sent a plume of mantle material into space. The heavier ejected material remained in Earth's gravitational field and later coalesced to form the moon. This theory explains the relative lack of volatiles and water in lunar rocks and similarities in chemistry of lunar rocks to earth's mantle and the lack of a substantial metallic core (since the earth's core was not breached during the impact).

In the last decade, a number of mass spectrometry techniques have been developed to determine additional chemical and isotopic compositions of minerals, which have caused geologists to rethink the collision theory—either in its entirety or to refine the parameters of the impact. For example, the 2010 and 2011 discoveries of measurable water in both lunar basalt glasses and in olivine inclusions is inconsistent with collision theory as it now stands. The ages of zircons in some of Earth's oldest rocks also do not support the collision theory. Today, the capture theory is making a comeback with a subset of geoscientists, who see less and less geochemical evidence for collision in the rock record. The capture theory—although it requires a "right place at the right time" set of interplanetary conditions that physicists and astronomers find unlikely—does explain some of the geochemical and geophysical data that cannot be explained fully by the collision model. As the Apollo rocks are reanalyzed using instrumentation that was not available in the 1970s, our ideas about the origin of the moon are guaranteed to evolve.

WRITTEN BY
SARAH K. CARMICHAEL PhD
Assistant Professor
Appalachian State University

ILLUSTRATED BY
LAUREN NASSEF
www.laurennassef.com

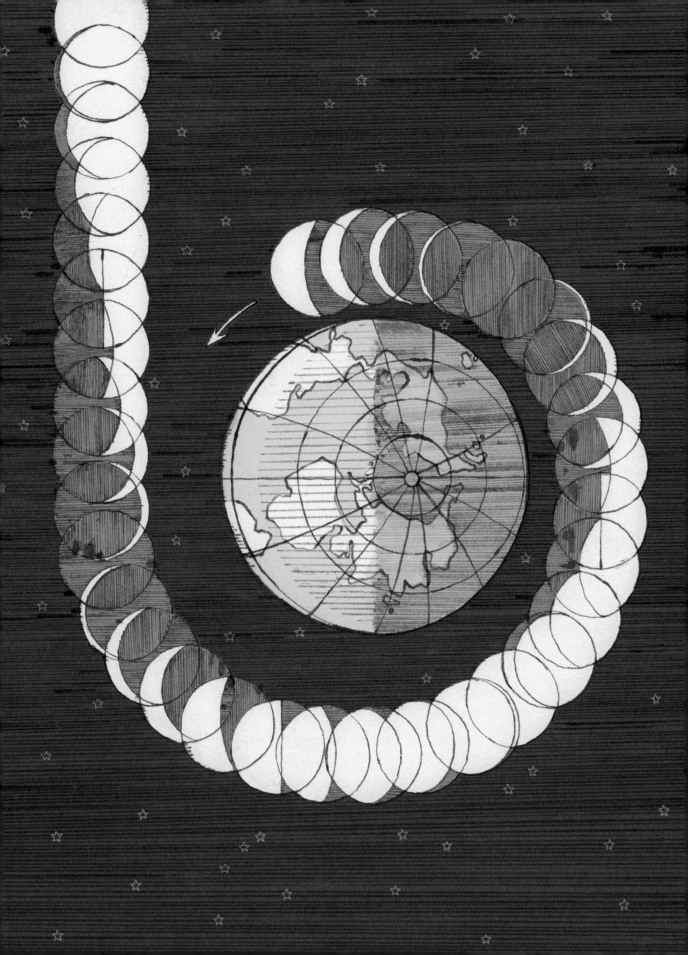

WHAT TRIGGERS REVERSALS OF EARTH'S POLARITY?

I F YOU WERE TO LOOK AT THE needle of a compass for a very long time, say a few million years, you would notice that from time to time the compass needle would flip halfway around. What used to be north would now be south. This is what is known as a "geomagnetic reversal."

To understand why geomagnetic reversals occur, one must know a little bit about Earth's composition. Humans, animals, and plants live on the solid surface of the earth called the crust. Some great distance beneath the crust is the outer core, which is made of iron, yet is so hot that it is a liquid, similar to what you'd see being poured at a steel mill. At the center of the earth is the inner core, which is also composed of iron. It is about the same temperature as the sun, yet is under such intense pressure that it is a solid. The liquid outer core is continually churning, with molten iron traveling in helical corkscrew patterns relative to the center of the earth. The combination of rotation and convection of the electrically conductive fluid (molten iron) creates what is called a dynamo, which is essentially a positive feedback loop that allows the earth to maintain a magnetic field.

Geomagnetic reversals result from slight changes in the flow of the molten iron layer inside the earth as it rotates around its axis. These changes may be due to the variation in rotational speed of the molten iron and the solids above and below it, or may perhaps be due to an outside event, such as a large meteor impact. While the precise causes are unknown, it is generally accepted that small disturbances in the liquid layer can upset a careful balance and ultimately lead to a geomagnetic reversal.

An observer looking at a compass over several million years might think that geomagnetic reversals occur very quickly. However, on a more human time scale, Earth's magnetic field becomes temporarily much more complex for a short period of time, say a thousand years. During this intermediate time period, multiple north and south poles are present before the earth returns to a condition of one north pole and one south pole. On average, geomagnetic reversals have occurred once every 300,000 years. However, it has been approximately 780,000 years since the last reversal occurred. Perhaps we will see the start of the next reversal sometime soon.

WRITTEN BY
FRITZ KREMBS PE, PG
Engineer / Geologist
Trihydro Corporation

ILLUSTRATED BY
LUKE RAMSEY
www.lukeramseystudio.com

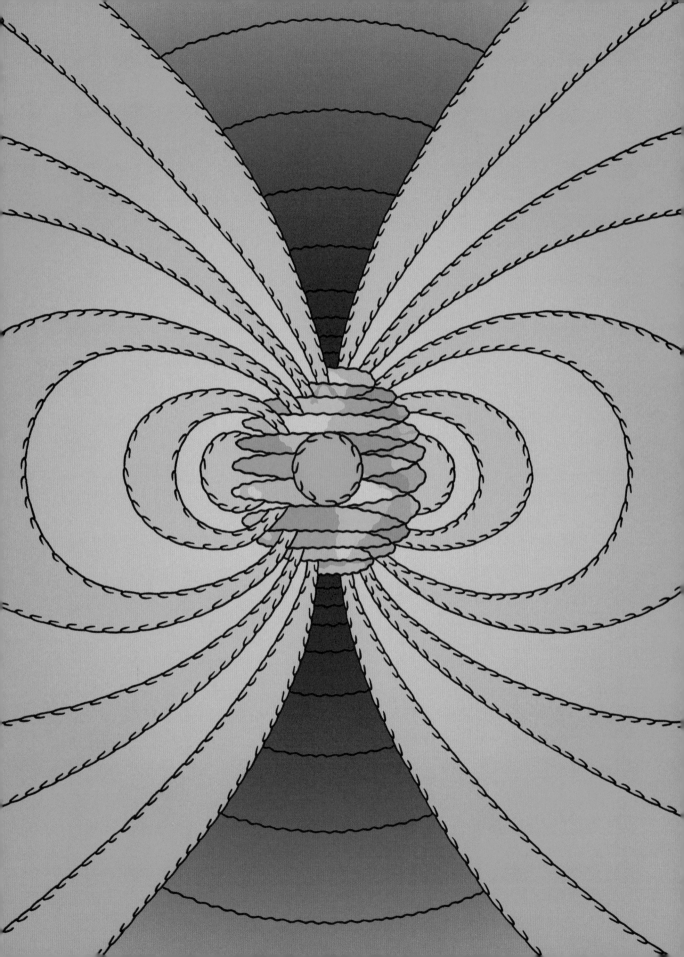

WHAT IS EARTH'S HUM?

FOR MANY YEARS, SENSITIVE seismographic instruments have been recording continuous oscillations of the earth's surface that are completely imperceptible to the human ear. These oscillations cover a wide range of periods—from 1 second to 1,000 seconds. Seismologists studying the nature of this seismic noise, called "Earth's hum," have several different hypotheses about the origin of the noise.

In one widely accepted scenario, wind energy is converted to ocean wave energy in the open oceans. Ocean wave energy is then transported to the fringes of continents as ocean gravity waves (or so-called infra-gravity waves at longer periods). Near coastlines, ocean gravity waves convert to solid earth propagating seismic waves when the water is shallow enough to allow their direct interaction with the seafloor. The noise then propagates through land masses and is recorded by seismographic stations.

For a long time, scientists considered the seismic noise to be a nuisance, preventing seismologists from detecting and studying weak seismic events like earthquakes and explosions. Only recently was it discovered that very useful information about the earth's structure can be extracted from the noise of the seismograms. Many studies are now dedicated to the origin and radiation features of the noise and its seasonal variations. Some very intriguing puzzles, like the very strong noise peak with a period of 26 seconds radiated from an unknown source in the Gulf of Guinea in the Atlantic Ocean near Africa, remain to be solved.

WRITTEN BY
ANATOLI LEVSHIN PhD
Lecturer
University of Colorado, Boulder

ILLUSTRATED BY
JULIA ROTHMAN
www.juliarothman.com

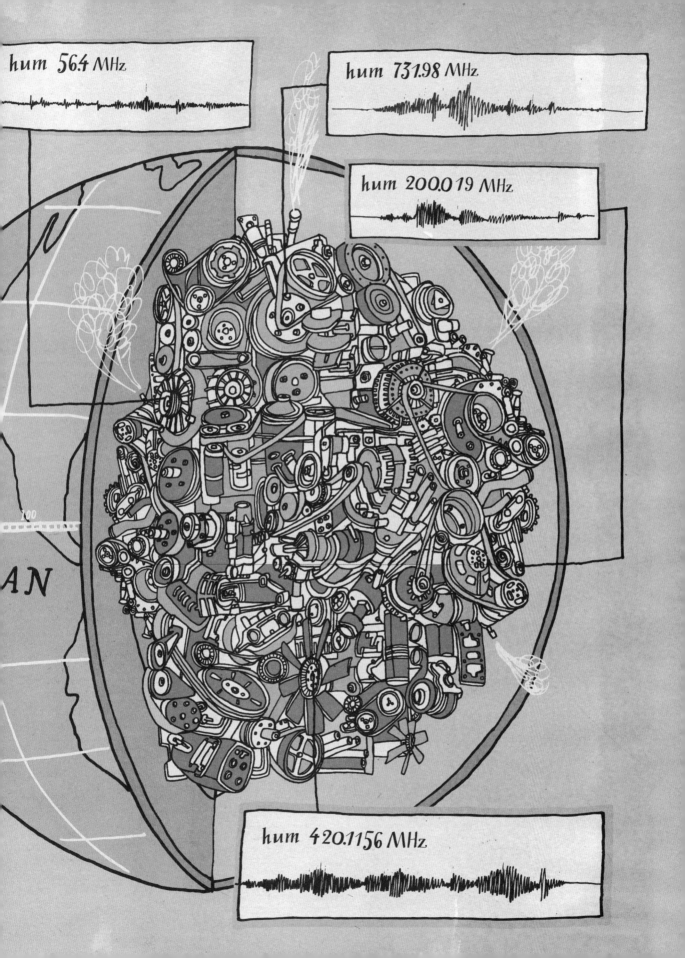

hum 56.4 MHz

hum 731.98 MHz

hum 200.019 MHz

hum 420.1156 MHz

WHAT DRIVES PLATE TECTONICS?

TODAY, IT IS WIDELY acknowledged that Earth's surface, which forms our ocean floors and continents, is in a perpetual state of movement and transformation. Instead of being a solid, unmoving shell as was once thought, Earth's surface is composed of several large pieces, or plates, that slide under, past, away from, or over neighboring plates. Where plates are meeting, edges are crushed together creating mountains and volcanic ranges. Where they are being pulled or pushed apart, plates are forming spreading zones, like the East African Rift, and places where new plate material is being created, such as on mid-ocean ridges.

Plate movement, or plate tectonics, occurs because the surficial plates are floating on a hot, dense, plastic-like layer of molten rock. As plate material is forced into or rises out of this lower layer, changes in density and temperature help maintain and reinforce the conveyor-belt-like current that perpetuates the movement, creation, and destruction of each plate. The rate at which new plate material is formed and destroyed is thought to be in equilibrium, with new material being created at approximately the same rate that older material is being destroyed.

Newly discovered mineral evidence suggests that these plate tectonics have been happening for more than four billion years. If these findings are correct, they will counter the long-held idea that Earth's surface four billion years ago was molten and inhospitable. If the plates were in place then, there is a possibility that life occurred on Earth millions of years earlier than previously thought.

WRITTEN BY
JULIE PADOWSKI
Research Hydrologist
University of Florida

ILLUSTRATED BY
MARC BELL
marcbelldept.blogspot.com

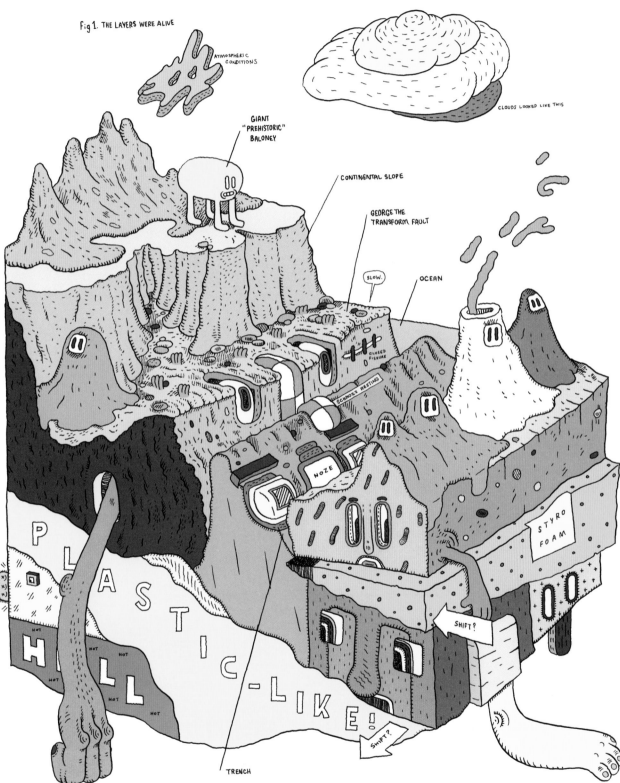

ARE EARTHQUAKES PREDICTABLE?

EARTHQUAKES ARE THE powerful evidence of the internal life of our planet. In the ancient times, earthquakes were understood to be actions of gods willing to show their strength and anger. At the beginning of the 20th century, in studying the San Francisco earthquake of 1906, H. F. Reid, Professor of Geology at Johns Hopkins University, concluded that the earthquake must have involved an "elastic rebound" of previously stored elastic stress. Reid's approach is now widely accepted by modern seismologists, but what caused the accumulation of stresses became clear only in the second part of the past century. These stresses came to be explained as the result of slow movements of the solid plates of the earth's lithosphere driven by the thermal convection of much softer viscous material in the underlying upper mantle, commonly called plate tectonics.

These plates, like pieces of ice floating in rivers during a spring breakup, push each other, dive under one other, or scrape edges. Their movement happens in very small steps due to the strong friction between plates. Each step results in an earthquake that breaks the resistance and permits relative movement of the plates.

Seismologists know earthquake-prone areas quite well, and they try to predict future geological events by looking for their precursors in seismic activity, stress and geodetic anomalies, radon gas emanation, and even in animal behavior. Alas, due to the great diversity of geological and tectonic environments, scientists still are not able to make accurate predictions of the times and exact locations of big earthquakes. For example, recent catastrophic earthquakes on Sumatra, Indonesia, and Japan, with an enormous number of human deaths and enormous destruction, had not been predicted.

WRITTEN BY
ANATOLI LEVSHIN PhD
Lecturer
University of Colorado, Boulder

ILLUSTRATED BY
ISAAC TOBIN
www.isaactobin.com

WHERE DOES EARTH'S WATER COME FROM?

ACH OF US CAME INTO being within a womb of water. Indeed, water is the womb of mortal existence— the vital matrix without which life as we know it would never have developed. The majority of your body is water, and three quarters of our world is covered by it. Empires have fallen due to drought and flood, and water's presence dictates whether our own civilization blossoms or wilts.

Water is everywhere, and both our fate and our identity are bound up in it, yet just how Earth became "the blue planet" remains unclear.

Our solar system formed when a large, cold, slowly rotating cloud of gas and dust collapsed into a disk. The sun ignited at its center, and the debris from this astronomical explosion slowly accreted into planets at successively distant orbits. It has long been recognized that temperatures were too high in Earth's neighborhood for minerals containing water to be stable. The source of Earth's water was therefore thought to be extraterrestrial, with the predominant theory suggesting that the water arrived via comets from the Oort cloud, a cosmic hail that bombarded early Earth with a deluge of ice.

Three comets, Halley's, Hyakutake, and Hale-Bopp, have come within reach of our analysis, but none have a signature consistent with the water found in our oceans. Ice from all three comets appears to have twice the proportion of deuterium, hydrogen's heavier sibling, which contains an additional neutron. This indicates that comets were probably not the primary source of water on Earth, though they would almost certainly have contributed some amount. Likewise, asteroids may have delivered some of Earth's water, but probably not the bulk of it.

In the light of these revelations concerning the composition of water in comets, recent years have seen a rise in the popularity of "wet-Earth" theories, which propose that water was present during Earth's initial formation despite the high temperatures. The suggested mechanism is adsorption: molecules of water sticking to the surface of stellar dust particles. Now no longer in gaseous form, the adsorbed water may have remained with the heaver solids that accreted to form Earth, while the sun's blast dispatched the lighter gases to the farther reaches of the solar system.

Irrespective of its original source, water was likely vaporized as the planet consolidated and internal pressures and heat rose. In time, however, Earth cooled sufficiently for the water vapor to condense, the first rains to fall, and life's gestation to begin.

WRITTEN BY
STUART JOHN MULLER PhD
University of Florida
The Blue Planet

ILLUSTRATED BY
JAMES GULLIVER HANCOCK
www.jamesgulliverhancock.com

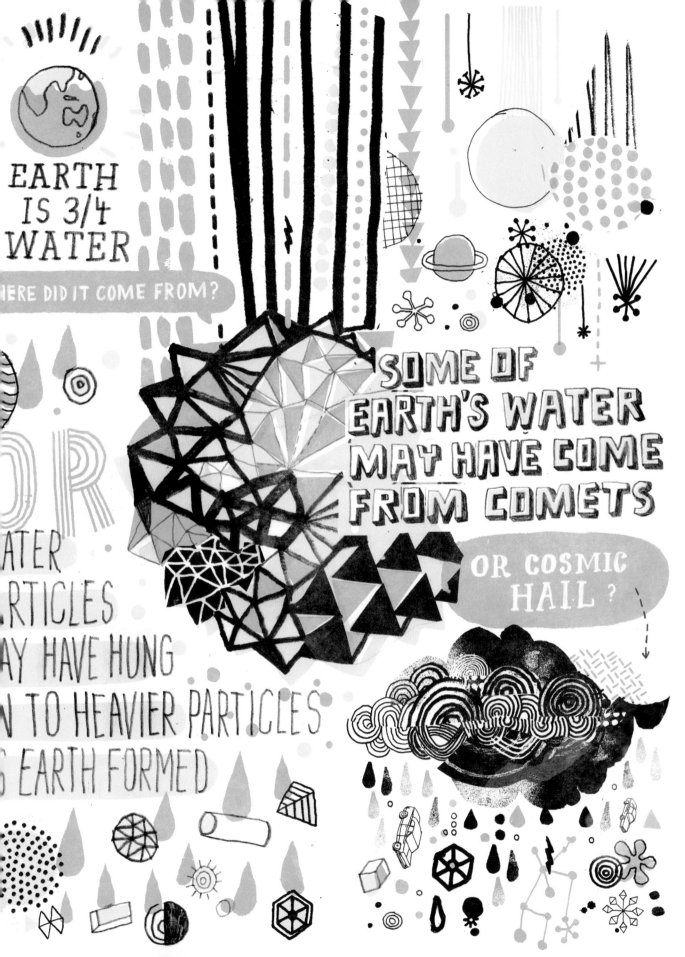

EARTH IS 3/4 WATER

WHERE DID IT COME FROM?

SOME OF EARTH'S WATER MAY HAVE COME FROM COMETS

OR COSMIC HAIL?

...ATER ...RTICLES ...AY HAVE HUNG ...N TO HEAVIER PARTICLES ...S EARTH FORMED

COULD CLIMATE CHANGE CAUSE OCEAN CURRENTS TO SHIFT?

THE GLOBAL CIRCULATION of the ocean is referred to as the "Ocean Conveyor Belt." It is estimated that it takes about 1,000 years for a single drop of water to circumnavigate the world when traveling this Ocean Conveyor Belt. The current results from a combination of temperature differences between air and water at the equator versus the poles, prevailing winds, salt concentration and water density, and subtle differences in the pull of gravity on the water.

Scientists theorize that the Ocean Conveyor Belt in the North Atlantic shut down 11 or 12 thousand years ago during the Younger Dryas or "Big Freeze." One explanation for the theory is that an ancient and massive glacial lake in North America expelled so much fresh water into the ocean that the circulation stopped, causing the largest, most severe and abrupt period of climate change in the last 12 thousand years. Much of the northern hemisphere experienced Siberian-style winters, with extreme cold and drought conditions that became more severe as one moved northward. The Indian monsoon system broke down, and tropical rainfall patterns moved southward. It is possible that as we continue to burn fossil fuels, deforest land, and increase factory farming conditions, abrupt climate change conditions could again occur.

As global warming causes the oceans and atmosphere to warm at an unprecedented rate, there will almost certainly be consequences for the Ocean Conveyor Belt, although it is impossible to predict exactly what those consequences will be. We are already experiencing more extreme climate events in a shorter period of time than usual, and initial data indicate that familiar ocean currents are decoupling from the atmosphere in unusual ways, such as the formation of unpredictable deep-ocean patterns with reduced longitudinal circulation. More heat in the climatic system will create a more chaotic and extreme environment, and the increased energy could fuel more active volcanoes, storm patterns, waves, and earthquakes.

WRITTEN BY
VICTORIA KEENER PhD
Research Fellow
East-West Center, Honolulu, Hawai'i

ILLUSTRATED BY
PIETARI POSTI
www.pposti.com

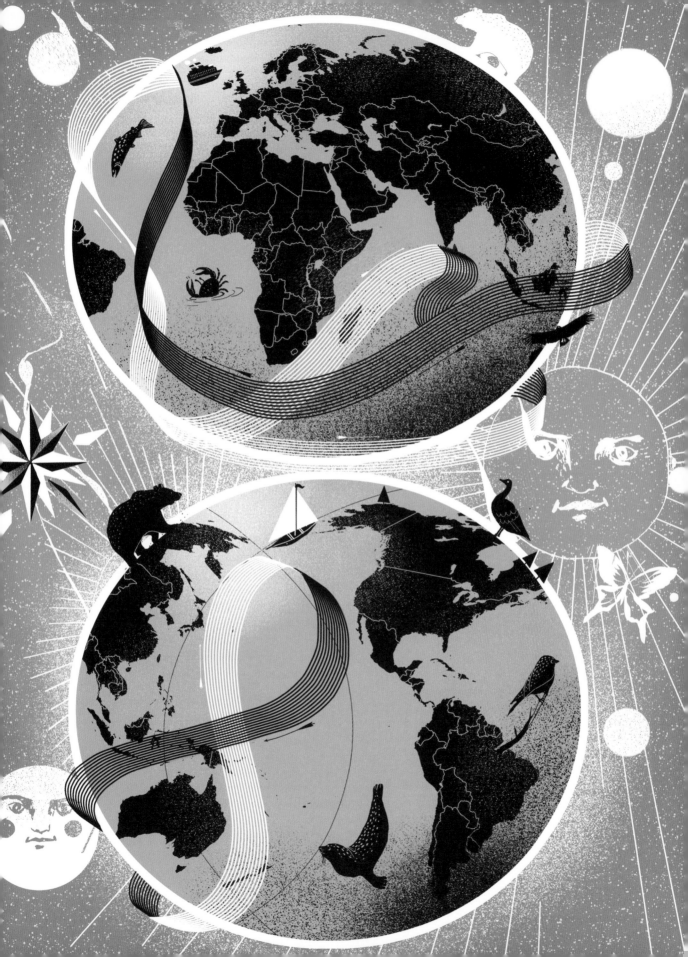

DO ROGUE WAVES EXIST?

L EGENDS OF UNPREDICTABLE, "freak" waves more than 100 feet high have long circulated among sailors in ocean folklore as destroyers of even the largest ships. While bathymetric conditions in enclosed and shallow bays can create favorable conditions for channeling in enormous waves, it is much more difficult to predict the occurrence of giant waves in the open seas. In 1958 in the enclosed Lituya Bay, Alaska, for example, an earthquake and the resulting massive undersea landslide generated a mega-tsunami that rose 1,720 feet high—nearly 500 feet taller than the Empire State Building. Until as recently as 1995, however, scientists doubted the existence of open-ocean rogue waves. In that year, the first enormous rogue wave was scientifically documented in the North Sea. Now, rogue waves with no obvious mechanical cause are known to occur on a semi-regular basis.

Scientists think that a perfect combination of events may be responsible for generating rogue waves. Waves propagating with different wavelengths can cause wave "focusing," in which the shape and size of obstacles and irregularities on the ocean floor cause the energy to compress at the front of the wave towards the shoreline. It is theorized that when these focused waves are superimposed on a chaotic ocean background, giant waves could form. Researchers are attempting to recreate rogue-wave-generating conditions in a laboratory wave tank by modeling ocean current focusing for local effects and non-linear wave oscillations described by a series of Schrödinger equations.

More than 100 large ships are still lost every year at sea, many under mysterious circumstances. Scientists and sailors have long suspected that rogue waves may be responsible for many of these disappearances.

WRITTEN BY
VICTORIA KEENER PhD
Research Fellow
East-West Center, Honolulu, Hawai'i

ILLUSTRATED BY
JOHN HENDRIX
www.johnhendrix.com

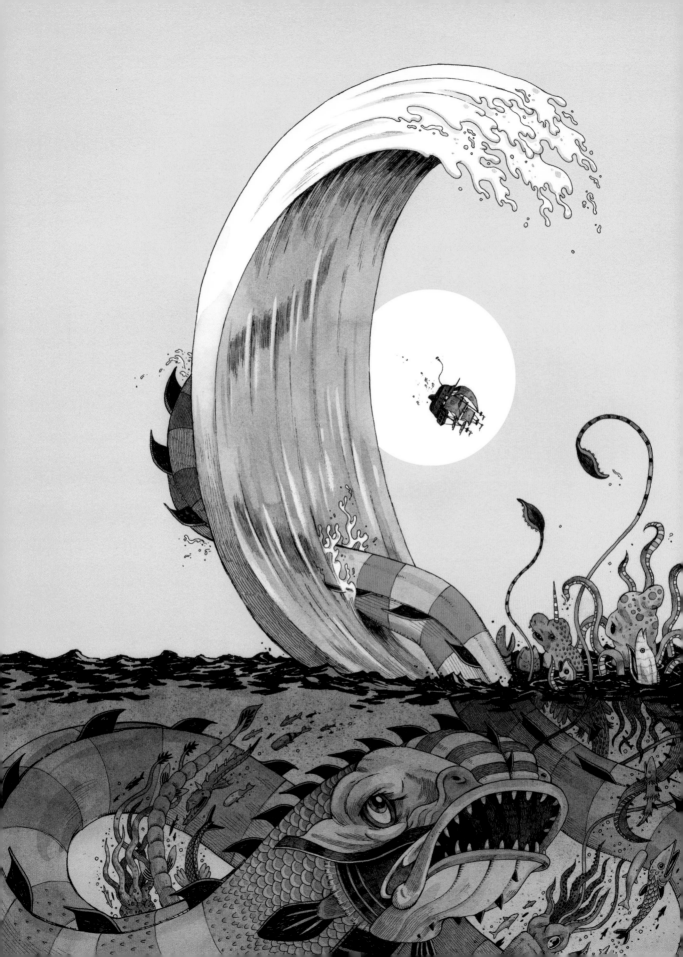

WHAT IS THE STRUCTURE OF WATER?

ATER IS A MOLECULE made up of two atoms of hydrogen (H) covalently bonded to a central atom of oxygen (O) by the sharing of two electron pairs. The remaining unshared electrons of the O atom exert a strong repulsive force, squeezing the hydrogen atoms together such that the angle between their bonds is 104.5°. Although the water molecule as a whole is neutral (has no net electrical charge), it is still "polar," having partial negative charge near the unshared O electrons and partial positive charge near the squeezed together H atoms. Since this polarity is consistent in every molecule of water, the positive end of one water molecule attracts the negative end of another, leading to the formation of an organized intermolecular structure in a process called "hydrogen bonding." In ice, these bonds form a uniform, rigid lattice structure. The structure of liquid water, however, is less well understood.

Traditionally, the local structure of liquid water was thought to be similar to that of ice, but set in motion: a loose, lattice-like array of molecules rapidly flickering into and out of different hydrogen bonding arrangements with their nearest neighbors. Recent X-ray studies suggest, however, the existence of other, different molecular configurations (a suggestion originally put forth in 1892 by Wilhelm Röntgen, who coincidentally also discovered X-rays). Some scientists theorize that linear or ring-shaped clusters of water molecules may be possible in addition to the lattice-like groupings. While it is still debated how many different configurations exist, how stable they are, and how frequently they occur, it's certainly possible that the structure of water may be more heterogeneous and dynamic than previously thought.

WRITTEN BY
DAVID KAPLAN PhD
Postdoctoral Researcher
University of Florida Ecohydrology Laboratory

ILLUSTRATED BY
HARRY CAMPBELL
www. drawger.com/hwc

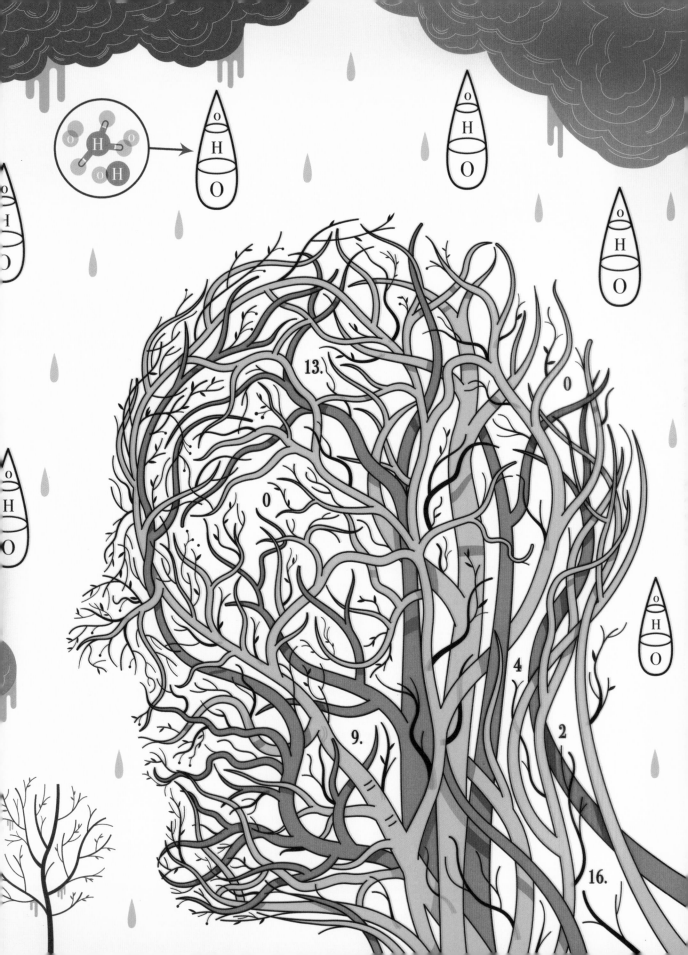

WHY DOESN'T WATER FREEZE IN CLOUDS?

WATER ON THE EARTH from rivers, wells, drinking fountains, and the faucets in our homes freezes when cooled to a temperature of 32^0F, the temperature that is usually given as the freezing point of water. This water contains very small amounts (parts per million) of impurities that originate from minerals in the soil or in the air. Clouds far above the earth contain pure water droplets and water vapor. Water that does not contain impurities can remain a liquid at temperatures below 32^0F. This is supercooled water.

Clouds may look similar to us, but inside they are all different. Scientists fly through clouds, create small clouds in laboratories, and use computer modeling to simulate clouds to develop hypotheses about how clouds grow and when and where droplets freeze. Water droplets have been found to form in the following way. The lower portion of a cloud is often warmer than 32^0F, but air temperature cools with increasing height above the earth. When the air temperature in the cloud reaches about 24.8^0F, droplets of pure water can begin to freeze when they come in contact with aerosol particles. Many droplets are frozen by 10^0F, most are frozen by 5^0F, and all cloud droplets are frozen when the air temperature reaches about -40^0F. Frozen droplets grow by collecting additional supercooled droplets, and when they are heavy enough, they fall and melt into raindrops when they reach temperatures above 32^0F.

For more than 60 years, field experiments have used aircraft to inject silver iodide nuclei into cumulus clouds in an effort to create rain. It is thought that the silver iodide nuclei freeze droplets quickly, and through a chain of physical processes, increase rainfall. However, there is no conclusive proof that "cloud seeding" produces more rain than would occur naturally.

WRITTEN BY
NANCY WESTCOTT PhD
Research Meteorologist
Illinois State Water Survey
Prairie Research Institute, University of Illinois

ILLUSTRATED BY
JING WEI
www.jingweistudio.com

WHY IS EACH SNOWFLAKE UNIQUE?

SNOWFLAKE FORMATION starts in a cloud composed of water droplets adhering to small particles of dust and dirt. This water evaporates and forms vapor within the cloud. In a process known as deposition, the water vapor turns directly into solid ice at very low temperatures. The microscopic ice crystals grow until they are heavy enough to begin falling—as snowflakes.

The traditional picture we have of snowflakes is one of a single ice crystal with six identical arms, but these perfect specimens are generally in the minority in nature. Snowflakes range in shape from hexagonal plates to long thin needles, to squat hexagonal columns, and even hollow columns. In addition, a large number of irregular snowflakes do not have a specific shape and even lack the almost universal hexagonal symmetry. The shape of the flake is determined predominantly by the temperature and humidity when the vapor turns into ice. At lower humidity, the platy and columnar shapes dominate; with higher humidity, the more complex six-armed beasts tend to dominate. For a fixed humidity, the shape alternates from platy to columnar to platy to columnar as the temperature falls from 0°C to -30°C. Why these shape transitions occur for small changes in temperature is not well understood.

So why is each snowflake different? As they fall, snowflakes are subjected to a myriad of microclimates with large variations in temperature and humidity. The final shape of a snowflake moments before it lands on your nose is determined by all the different microclimates through which it has passed. Because the paths are unpredictable and highly variable, no two snowflakes pass through the same set of microclimates and as a result each snowflake is unpredictably unique.

WRITTEN BY
ANDREW MILLER PhD
Aquatic Chemist

ILLUSTRATED BY
ROMAN KLONEK
www.klonek.de

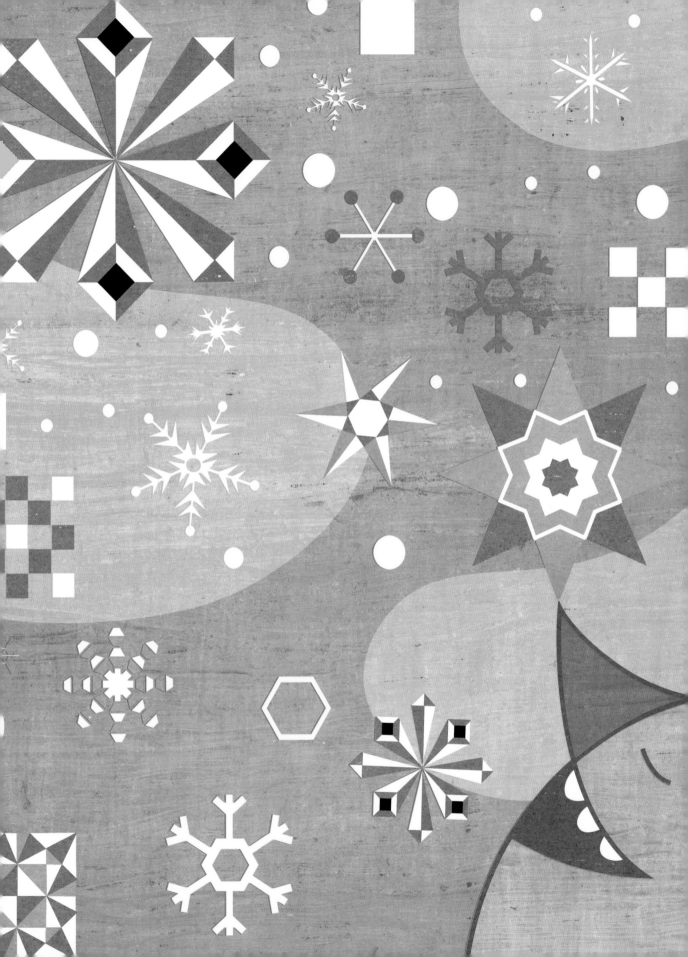

WHAT CREATES THE TORNADO VORTEX?

To FORM A TORNADO, A cloud must be present. The type of cloud is called a "cumulus" cloud. We recognize cumulus clouds as the bringers of thunderstorms, with lightning, thunder, and rain or hail. If this cloud is many square miles across, it is called a "supercell." Supercells often produce tornadoes.

A tornado is a whirling column of wind extending downward from the bottom of a cumulus cloud. If it reaches the ground, it is called a tornado, otherwise it is called a funnel cloud. The formation of a tornado is called "tornadogenesis."

Strange as it may seem, the whirling column of wind that creates tornadoes often gets its start when winds near the ground have a slow speed while at the same time winds higher up (for example, 1,000 feet or more) are moving faster. This produces a rolling motion in the air similar to rolling a log along the ground or a pencil on your desk.

There are currently three different theories about how tornadoes form, and all three may be correct, but first we have to understand how the cloud forms. Then we will see how the rolling log of wind turns and becomes a vertical whirling column of wind.

Cumulus clouds start to grow when air near the ground gets hotter than the air above it, producing convection. As it rises, the warm air cools and water vapor condenses. For example, when you go outside on a cold winter day, you can see your breath form as a little cloud when you exhale. Your breath contains water vapor, and the cold air causes the vapor to turn to liquid droplets that you can see before they quickly mix with the air and disappear. This same process occurs in cloud formation. As the convection continues, the cloud grows higher into the sky.

As the sun heats the earth during the day, the rolling log of air becomes part of the convection. It may begin to tilt as a result of the convection as some parts are lifted upwards and other parts stay on the ground. This is similar to the way you might lift a log at one end while the other end stays on the ground. You can try this with your pencil. Roll it along the edge of your desk with about an inch over the edge. As you continue to roll along, lift the outer edge with you fingers. It's tricky!

As the air lifts and tilts, two things happen. First, the rolling layer of air becomes a vertical column of rotating air (just like your pencil), and, second, a cloud forms due to convection and within it is the rotating column of air.

One theory about how the rotating column of air becomes a tornado is called the "Dynamic Pipe Effect."

If the column rotates more and more quickly, it will build downward because air can enter only through the ends of the column, like a pipe, not through the column's sides. The end of the pipe (the tornado) draws air in. As air enters at the pipe's bottom, it also begins to spin. The tornado grows as more and more air is drawn in until the end of the tornado comes in contact with the ground.

A second way that tornadoes develop is when winds meet head-on. This is called convergence. If the converging winds extend from the earth's surface high up into the atmosphere, a thunderstorm or supercell that contains a rotating column of air several thousand feet high can result. Growing from the ground upward, this kind of tornado can develop very rapidly.

A third theory posits that in some supercells a region of very dry air is pushed down toward the ground. If the supercell is moving in one direction, usually toward the northeast or east, the sinking area is found in the rear (southwest) side of the cloud and is called a "Rear Flank Downdraft" (RFD). The RFD wraps around the rotating column of air and then forces the rotation to increase and lower to the ground, producing the tornado. Meteorologists are continuing to study the RFD to determine what part it plays in tornadogenesis.

WRITTEN BY
AUSTIN L. DOOLEY PhD
Purchase College, Purchase NY

ILLUSTRATED BY
JON HAN
www.jon-han.com

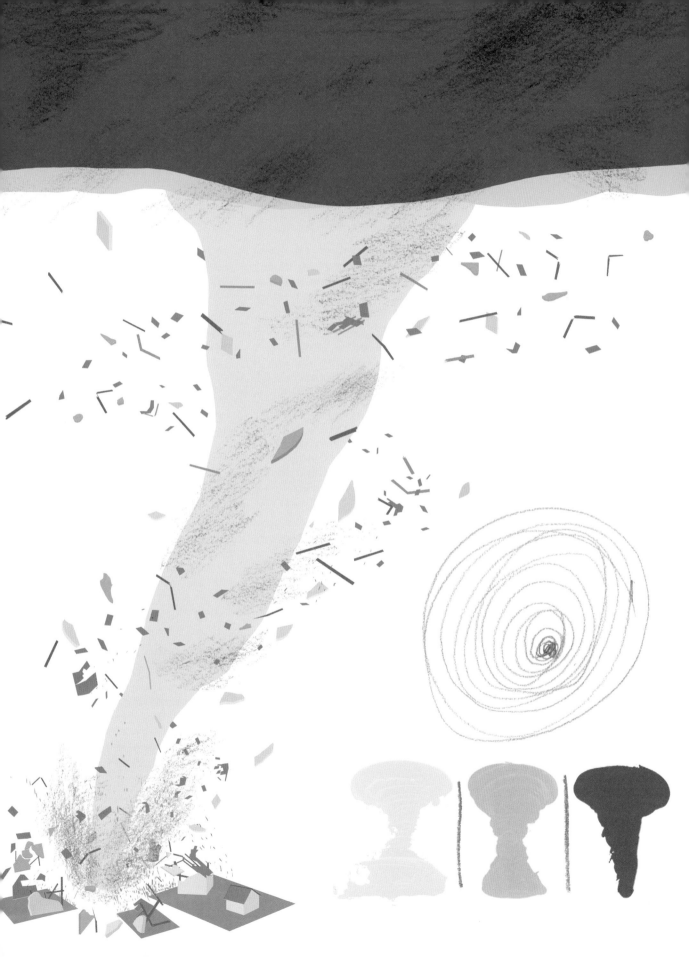

WHY IS THE WORLD GREEN?

THE EARTH IS GREEN. Almost anywhere you look, plant matter is abundant. From tropical forests to high altitude deserts, plants reign supreme. And therein lies the question. Why isn't all this seemingly readily available food being eaten much faster than it is? The world is not overrun with squirrels or rabbits because their population numbers are controlled by their predators, so why aren't plants being better controlled?

Several hypotheses have been proposed to explain the "Green Earth" question. Some researchers suggest that plants are very good at being unpalatable and that a myriad of chemical and physical defense strategies are responsible for plants being very good at resisting predation and staying one step ahead of adaptations developed by herbivores to overcome such defenses. Recent experiments in which top predators have been excluded from the food chain show that the earth may, in fact, be green because top predators keep the herbivore population low, and consequently reduce the herbivory pressure on plants.

The complete explanation is likely to involve a combination of the two hypotheses, with plants continuously edging out herbivores in an evolutionary arms race of better and better defense mechanisms, as well as top predators ensuring that the herbivore population remains relatively small.

WRITTEN BY
ALEXANDER GERSHENSON PhD
Adjunct Professor, SJSU
Principal, EcoShift Consulting

ILLUSTRATED BY
MICAH LIDBERG
www.micahlidberg.com

CAN EVOLUTION OUTPACE CLIMATE CHANGE?

VOLUTION OCCURS WHEN heritable traits lead to selective survival in a particular environment. As the environment changes, as in the case of a famous Light Peppered Moth that changed coloration over several generations in response to industrial pollution in London, some traits begin to confer higher fitness than others. The biggest challenge for any given species' adaptation to a changing environment is the rate of change. In the case of climate change, there are many indications that change may come too fast for a lot of species to have time to adapt. When we consider the scale of change that has already occurred and the projected rate of change in the next 100 years, it becomes clear that for some species, adaptation to climate change may be out of the question due to their long generation times, low reproductive rates, or limited ability to migrate. In some cases, whole ecosystems, such as the California alpine meadow ecosystems of the southern Sierra Nevada, are projected to diminish if not disappear completely.

Yet some species may be able to adapt to the changing climate rapidly enough, either through migration or a change in the prevailing genotypes that will confer higher fitness in the changing world. Unfortunately, species do not exist in a vacuum. Although some species within a community may successfully adapt to the changing climate, others undoubtedly will diminish, changing the structure of the community and reducing biodiversity. It is projected that as much as 40 to 60 percent of all species on the planet will be threatened by climate change in the next 100 years under the worst-case emission scenario, and the change in communities that will follow will affect even those species that are capable of managing the direct climatic changes.

WRITTEN BY
ALEXANDER GERSHENSON PhD
Adjunct Professor, SJSU
Principal, EcoShift Consulting

ILLUSTRATED BY
YELENA BRYKSENKOVA
www.yelenabryksenkova.com

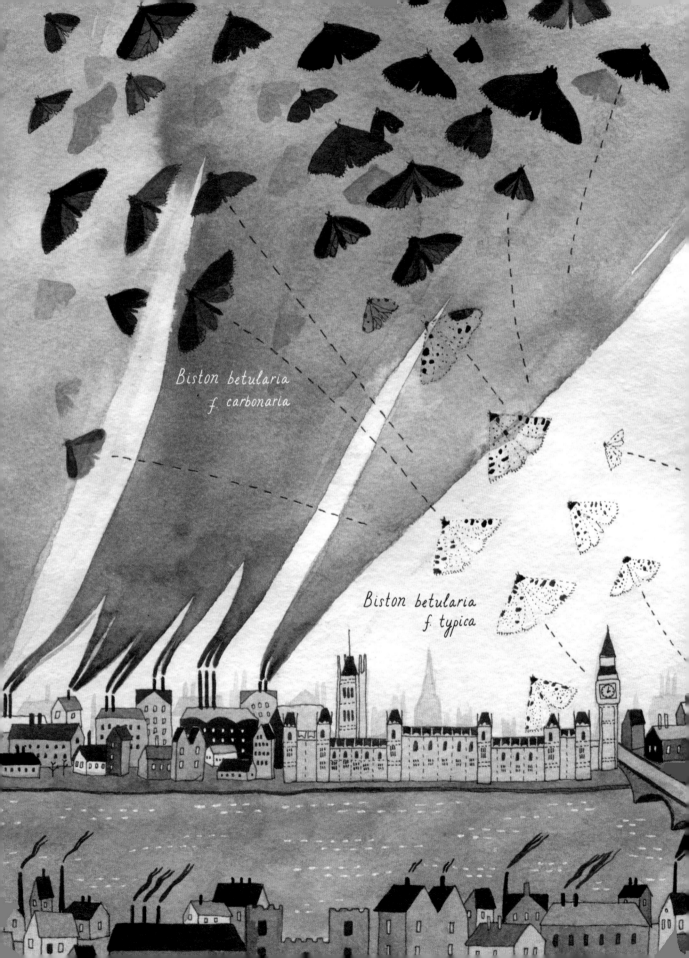

Biston betularia
f. carbonaria

Biston betularia
f. typica

WHERE DID LIFE COME FROM?

URRENT SCIENTIFIC consensus estimates that Earth was created about 4.5 billion years ago, with the earliest forms of life occurring about one billion years later. When the oceans and an atmosphere formed, they made conditions favorable for the creation of life in the so-called Primordial Soup: the presence of water, high heat and pressure, elements in volcanic dust and from outer space, and bursts of energy from lightning or radiation. The process by which biological life is created from inorganic compounds is called abiogenesis, and there are several competing theories as to how these first life-forms were created.

In 1952, a famous project called the Urey-Miller Experiment sought to recreate in a laboratory the conditions on primitive Earth by which the 20 naturally occurring amino acids,

the building-blocks of protein-based life, were formed. Miller and Urey put chemical compounds known to exist early in Earth's formation—water, methane, ammonia, and hydrogen gas—in a sealed container, which was then heated and exposed to electric sparks to simulate lightning. After only one week, the researchers found that all 20 of the amino acids had been created in varying concentrations, as well as other amino acids that are not found in terrestrial life. This showed that it was quite possible to create complex organic molecules from simple compounds found on early Earth.

Two current abiogenesis theories are the "RNA World" and the "Iron-Sulfur World" hypotheses. In the RNA World theory, ribonucleic acids (as opposed to DNA) could have formed from individual nucleic acids floating in the Primordial Soup as the first

self-replicating molecules and catalysts of chemical reactions. In fact, leftover RNA enzymes still present in our own bodies support to the RNA World theory. The Iron-Sulfur World hypothesis suggests that deep in the ocean, hot hydrothermal vents provided the elements and energy necessary to catalyze life on specific metallic rocks—that metabolism predated the ability to pass on genetic information.

Recent research may point in new directions. For example, viruses may have played a role in early RNA to DNA transition. Other theories range from life having an extraterrestrial origin to life having been formed deep in the core of the earth. Each generation of scientists continues to add pieces to the puzzle, and while there is much left to study, the amount we have learned about life's origins in just the last 60 years is impressive.

WRITTEN BY
VICTORIA KEENER PhD
Research Fellow
East-West Center, Honolulu, Hawai'i

ILLUSTRATED BY
BEN WISEMAN
www.ben-wiseman.com

WHAT DEFINED DINOSAURS' DIET?

EPRESENTATIONS OF DINO-saurs in popular films and on TV might lead one to believe that cavemen were a popular snack for these prehistoric beasts. However, one thing we do know for certain about dinosaur diet is that people weren't on the menu—dinosaurs were extinct long before humans ever walked the planet. Scientists remain uncertain, though, as to what and how dinosaurs ate, and they are attempting to piece this information together from different kinds of fossilized evidence.

Through comparing fossilized dinosaur teeth and bones to those of reptiles living today, we've been able to broadly categorize the diets of different kinds of dinosaurs. For example, we know that the teeth of the Tyrannosaurus Rex are long, slender, and knife-like, similar to those of the komodo dragon (a carnivore), while those of the Diplodocus are more flat and stumpy, like those of the cow (an herbivore). However, whether carnivorous dinosaurs were hunters or scavengers (or even cannibals!) and whether the herbivorous ones noshed on tree leaves, grasses, or kelp is still uncertain.

Since we can't observe an extinct creature's feeding behavior directly, we're forced to consider what's left behind—literally. Fossilized dinosaur feces, called "coprolites," are one way scientists reconstruct what was eaten. However, it can be tough to conclude definitively which dinosaur originally deposited which coprolite. We can also sometimes get hints from fossilized remains of meals, though distinguishing whether this last meal was a dietary staple or actually the cause of the animal's demise is tricky. Learning more about dinosaur diet and feeding behavior will help us understand better how animals adapt (or don't) to different environmental conditions through time.

WRITTEN BY
MARGARET SMITH MA, MSLIS
Physical Sciences Librarian
New York University

ILLUSTRATED BY
MEG HUNT
www.meghunt.com

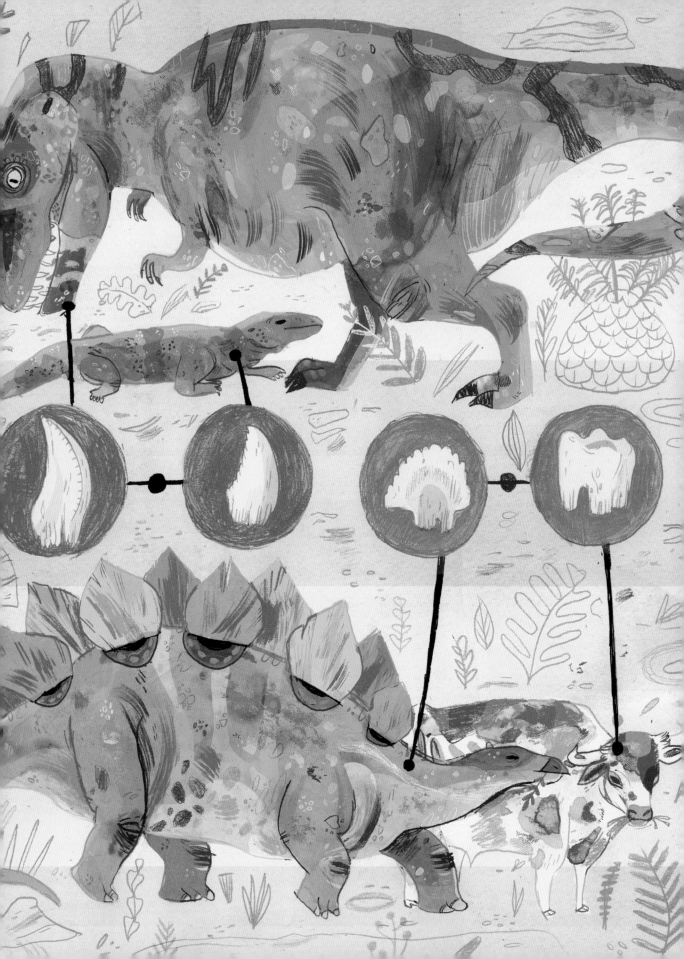

WHAT CAUSES AN ICE AGE?

CLIMATE-WISE, OUR PLANET straddles a habitable "Goldilocks zone" between frozen, distant Mars and scorching Venus. However, periodically in Earth's history, swings in climate have been sufficient to cap the planet in ice and provoke massive extinctions.

Our climate is driven by many cycles, some of which make the earth warmer or cooler. Many of these can provide stabilizing negative feedback effects: One warming trend is cancelled out by a cooling trend or vice-versa. In contrast, some cycles fuel their own growth. For example, a buildup of ice reflects sunlight away like a mirror, thus cooling the planet even more. It is thought that shifts in one or more of these self-fueling cycles is what causes the runaway downhill temperatures of an ice age.

Factors other than self-fueling cycles also help shape our climate. Most important of these is the sun: the amount of solar radiation that reaches the earth shifts due to variations in the earth's orbit. Other dynamic earthly processes are also involved. For example, continents slide on molten rock, changing how much of the earth is covered in ice near the poles and blocking ocean currents that might transport warm equatorial water to the earth's chilly extremities. Even the shifting mosaics of light and dark colors brought on by ice, clouds, continents, and vegetation change the amount of sunlight that heats the earth or is reflected back to space. While multiple reinforcing feedbacks seem to be the cause of ice ages, few specific triggers are known.

Now that we are in the anthropocene era, when humans are affecting climate, scientists have begun reevaluating biology's role. For example, the shifting boundaries between darker, heat-absorbing grasslands and reflective desert sands affect climate, as do blooms of algae which consume warming gases out of the air, and promptly bury them deep in the ocean upon dying. Could these biological processes have been the spark that set past ice ages in motion? Humans have been starting fires and clearing land for agriculture for many millennia, and more recently, we have been increasing atmospheric greenhouse gases through combustion of fossil fuels for energy. Could we be preventing or hastening the formation of future ice ages?

WRITTEN BY
CASEY SCHMIDT PhD
Research Biogeochemist
University of Florida

ILLUSTRATED BY
JON KLASSEN
www.burstofbeaden.com

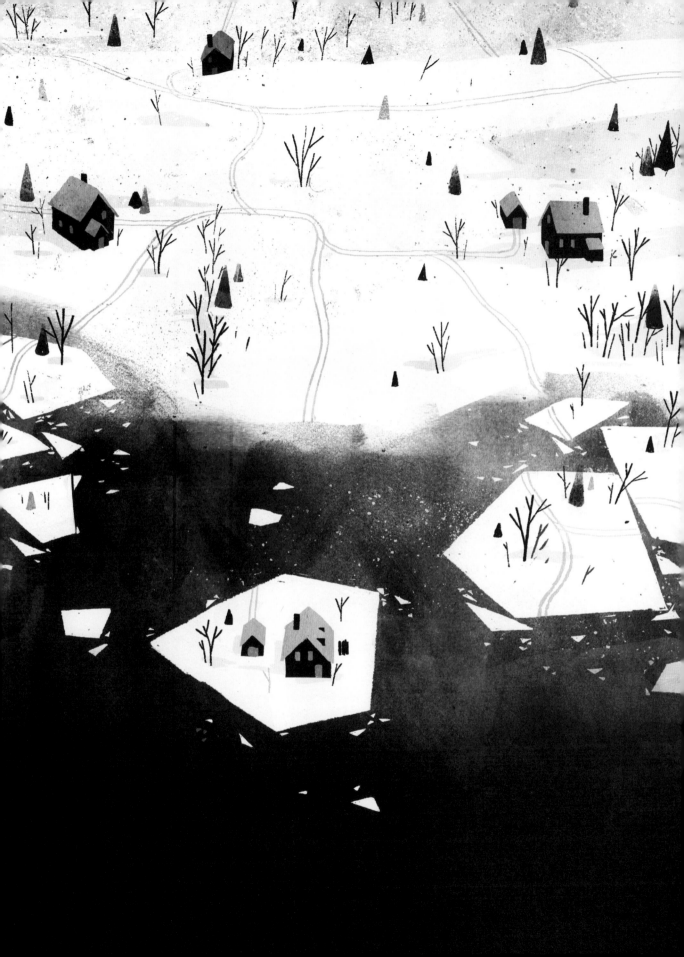

WHERE ARE THE FOSSIL CHIMPANZEES?

HUMANS AND CHIMPAN-zees shared a common ancestor approximately 6 million years ago. The hominin fossil record documents the evolutionary changes that occurred in our lineage from 6 million years ago to today. "Lucy" is perhaps the most well-known fossil hominin. She is a remarkably complete *Australopithecus afarensis* skeleton from Ethiopia, dated to 3.2 million years ago (mya). There are the Neanderthals, for which we have an abundance of fossils, ranging in age from about 200,000 to about 30,000 years old. *Ardipithecus ramidus* was a recent fossil discovery, also from Ethiopia, dated all the way back to 4.4 mya. The last 60 years in paleoanthropology have yielded many informative new finds that have significantly advanced our understanding of how humans evolved. But something is still conspicuously absent. Chimpanzee

fossils. A single chimpanzee fossil was found in Kenya in 2005 and dated to 500,000 years ago. But, what about chimpanzee ancestors that lived deeper in time?

Picture it, 6 million years ago, the population that eventually led to humans split from the population that eventually led to chimpanzees. One lineage went one way—and resulted in hominin species like Lucy—and one absolutely must have gone another. The ancestors to modern chimpanzees were certainly living during the time of Ardipiths, Australopiths, and Neanderthals. But where are the fossils? It's not a missing link; it's more like a missing lineage.

There are several reasons for the absence of chimpanzee fossil material. First, fossil preservation is biased. The environment that a species lived and died in affects how fossils form. Chimpanzees live primarily in humid,

tropical forest environments. Forested habitats are not conducive to fossil preservation because skeletal remains decay rapidly on the forest floor. Meanwhile, the hominins were living in drier places. Second, some specimens currently described as fossil hominins might actually be fossil chimpanzees. Human ancestors closer to 6 mya were less morphologically distinct from chimpanzee ancestors than those two species are today. This is an inherent difficulty in extinct species identification. Third, there may be ascertainment bias, or bias toward finding only what you are looking for. As you can imagine, no one is hunting for these forest chimpanzee fossils. So, the missing fossils are one of those curious evolutionary questions for which we can't find the answer, or the fossils, partly because we aren't looking.

WRITTEN BY

JULIA M. ZICHELLO
PhD candidate
Physical Anthropology
The Graduate Center, City University of NY

ILLUSTRATED BY

MATTIAS ADOLFSSON
www.mattiasadolfsson.se

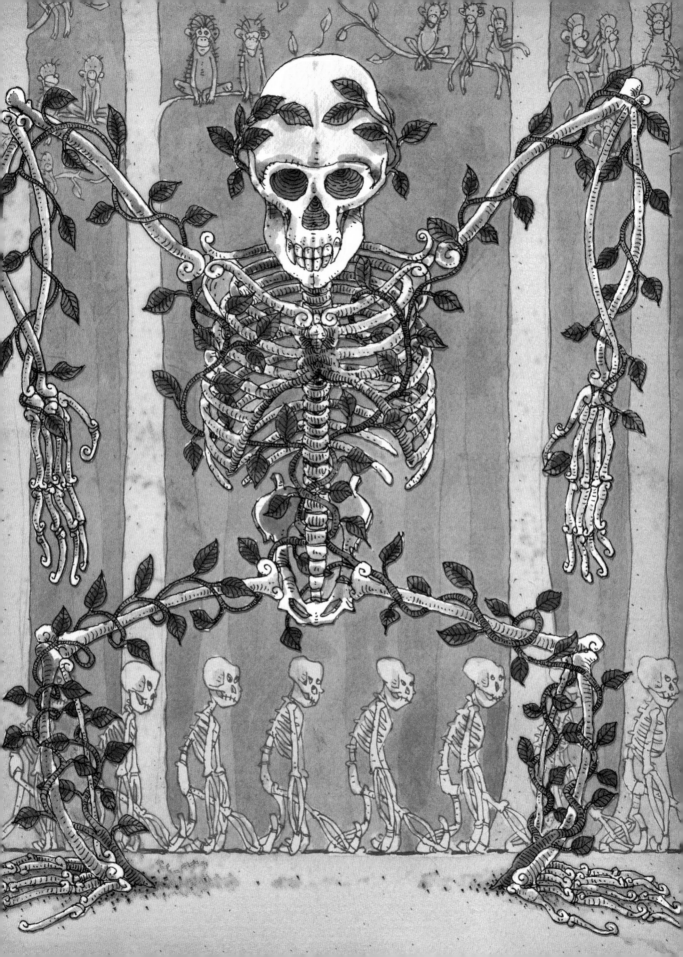

WHAT CAUSED THE EXTINCTION OF THE NEANDERTHALS?

NEANDERTHALS WERE a group of hominins (humans and their ancestors) who lived in Europe and the Middle East from approximately 130,000 until 30,000 years ago. The last Ice Age was at its maximum extent during this time, and Neanderthals with their stocky build were well suited to this cold climate. There is some evidence that they had a complex society and language. Their disappearance is one of the great mysteries of human evolution.

There are several hypotheses as to what caused their extinction. One idea is that at the end of the Ice Age, Neanderthals were unable to cope with the erratic climate that caused the forests in which they hunted to become grassland. Another idea is that when modern humans entered Europe approximately 50,000 years ago, their more slender build, more complex language, greater creativity, and versatile toolkit enabled them to out-compete the Neanderthals. Modern humans may have been better hunters in the open plains. A final hypothesis is that Neanderthals did not really become extinct, or at least not completely. A study comparing ancient DNA from Neanderthal fossils to modern human DNA concluded that Europeans have between 1 and 4 percent Neanderthal DNA, indicating that ancient humans bred with Neanderthals.

WRITTEN BY
ALISON A. ELGART PhD
Assistant Professor
Florida Gulf Coast University

ILLUSTRATED BY
MIKKEL SOMMER
mikkelsommer.com

WHAT EXPLAINS LATITUDINAL PATTERNS IN SPECIES DIVERSITY?

I T IS A WELL-KNOWN FACT THAT species diversity increases as latitude decreases and that there are more species per unit area in, for example, the Amazon basin than in arctic tundra. This pattern of biodiversity is sometimes referred to as the latitudinal gradient in species diversity. But, why does this phenomenon exist? This is a beguilingly simple, yet fundamental, question in ecology that—to date—has no easy answer.

In the 19th century, natural historians such as Charles Darwin, Alfred Russel Wallace, and Alexander von Humboldt explored tropical South America and Southeast Asia and were struck by the extreme biodiversity in these regions relative to their homelands of England and Germany. Early in the 20th century, ecologists proposed that greater species diversity at lower latitudes was a function of soil fertility. That is, since tropical soils were putatively richer than soils in temperate zones, they could support more biota. However, we know that this is not true and that tropical soils can be virtually devoid of the soluble minerals needed by plants.

Many hypotheses have been proposed more recently. For example, a commonly cited argument is that the less extreme climatic seasonality at lower latitudes results in a more stable environment that more species can tolerate. Others have suggested that the greater solar irradiance at the equator results in a greater overall net primary productivity that can support a greater diversity of species. It has also been suggested that the tropical forests spanning such a large area of the planet at lower latitudes can support more species with larger ranges and population sizes, which limits the likelihood of species extinction. However, all of these hypotheses have been critiqued, and none have been fully predictive or robust enough to explain latitudinal gradients in species numbers. Identifying mechanisms that can explain global biodiversity patterns remains among the most challenging goals in modern ecology.

WRITTEN BY
JOANNA E. LAMBERT PhD
Professor
The University of Texas at San Antonio

ILLUSTRATED BY
LOTTA NIEMINEN
www. lottanieminen.com

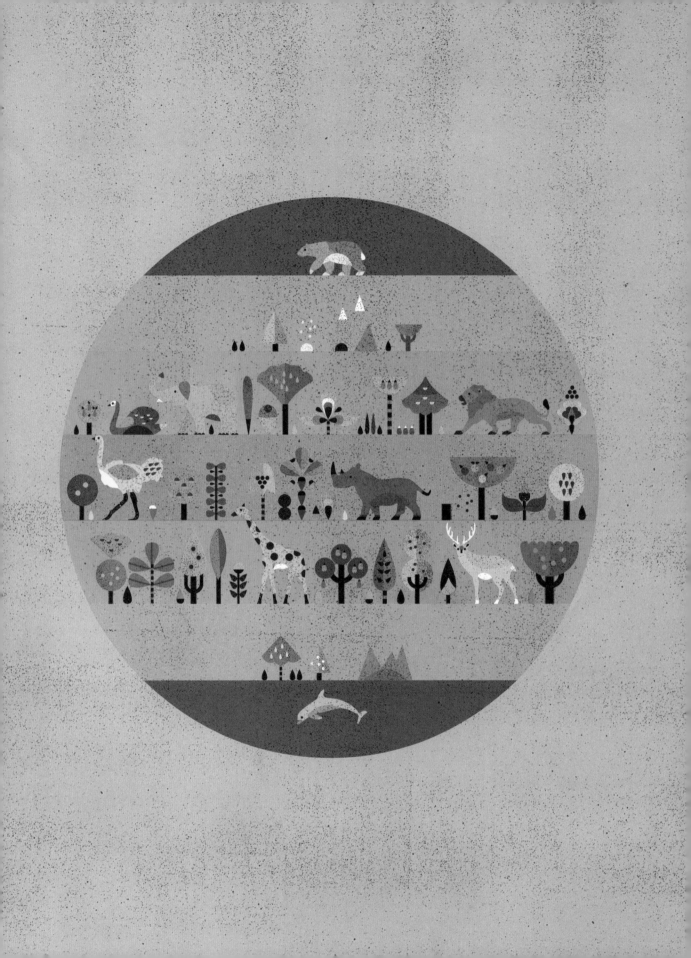

WHAT DETERMINES THE SIZE OF A PRIMATE SOCIAL GROUP?

THE BENEFITS OF GROUP living are many. Living in groups provides protection against predators because each individual gets diluted amongst the group, and there is the opportunity for more eyes to recognize danger. Group living also has feeding benefits, since larger groups can cooperate to defend important food sources and to win contests over smaller groups, and more individuals are available to search for acceptable food. Living in a group also typically provides increased mating opportunities over living alone, and there are opportunities for shared infant care. At the same time, the costs of group living are also apparent. Individuals within larger groups often receive less food per individual than those in smaller groups, and food competition is prevalent. Individuals living in larger groups are more conspicuous to predators, and they may also be more susceptible to disease.

Though the costs and benefits of group living are apparent, an unresolved issue is how to predict group sizes of primates among and within species. For example, forest mandrills live in groups of 500 or more, while other monkeys live in very small groups of 6 to 12, as do black-and-white colobus monkeys. Still other primates, like orangutans, are solitary, and others like titi monkeys are pair bonded. Even within the same species, primate groups can vary from 20 to more than 200 individuals.

The determinants of primate group sizes are a puzzle. One explanation is that ecology constrains group size so that in areas where there is less food, there are lower group numbers because food competition limits the number of individuals that can remain in social groups. Another theory is that primate species with a larger ratio of neocortex to total brain size are able to live in larger groups due to greater cognitive abilities since the greater abilities allow individuals to remember each other and social relationships. Yet another theory suggests that the management of time budgets, including time for travel, feeding, digestion, and social activities constrains group sizes. It is likely that a combination of ecological and social factors affect primate group size. Unfortunately, many primates and their habitats are disappearing, so we need to act fast in order to unravel this mystery.

WRITTEN BY
JESSICA ROTHMAN PhD
Assistant Professor
Hunter College of the City University of New York

ILLUSTRATED BY
STACEY ROZICH
www.staceyrozich.com

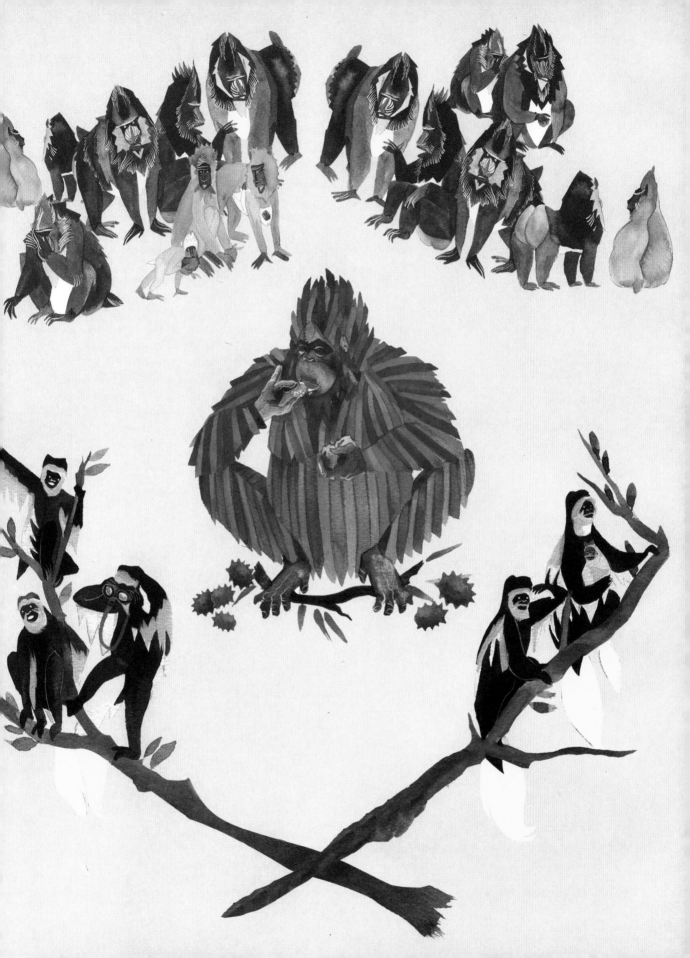

WHY DO PRIMATES EAT PLANTS THAT PRODUCE STEROID MIMICS?

MOST PRIMATES, INCLUDing humans, depend heavily on plant foods to meet their nutritional needs. These plants contain many chemical compounds in addition to the proteins, carbohydrates, lipids, vitamins, and minerals that are essential to proper biological functioning. Humans and other primates make use of some of these compounds, such as caffeine, to alter their physiology and behavior. Other plant chemicals may be avoided because of their toxicity, or simply ingested as an unintended consequence of eating a plant for its nutritional value.

One class of plant compounds, the phytosteroids, has the potential to alter the health and reproduction of both males and females. Phytosteroids mimic the activity of endogenous steroid hormones in primates and consequently alter primate physiology and behavior. Steroidal plants, such as soybeans, are routinely consumed by humans and non-human primates. Considering only those plant compounds that mimic endogenous estrogens, more than 160 phytoestrogens have been discovered in more than 300 plant species from 32 plant families.

One type of steroidal plant, the genus *Vitex*, has an apparent contraceptive effect on wild female primates. Little is known about why primates eat such plants. It may be that primates gain improved health or control over the timing of reproduction by consuming plants that produce phytosteroids. Alternatively, plants may benefit from producing these compounds by suppressing fertility, thereby reducing the number of animals eating the plants. If this were the case, primates would tend to avoid such plants unless the nutritional benefits outweighed the reproductive costs. Or, similarities between phytosteroids and endogenous primate steroid hormones may simply be a coincidence of chemistry, with no significant benefits for either plant or primate. Nonetheless, it is possible that hormonal interactions between plants and primates have played an important, thus far neglected, role in the biology of primates. Current field studies on wild primates and the plants they consume are attempting to address the importance of phytosteroids to primate ecology and evolution.

WRITTEN BY
MICHAEL D. WASSERMAN PhD
Postdoctoral Fellow
McGill University

ILLUSTRATED BY
OLE TILLMANN
www.ole-t.de

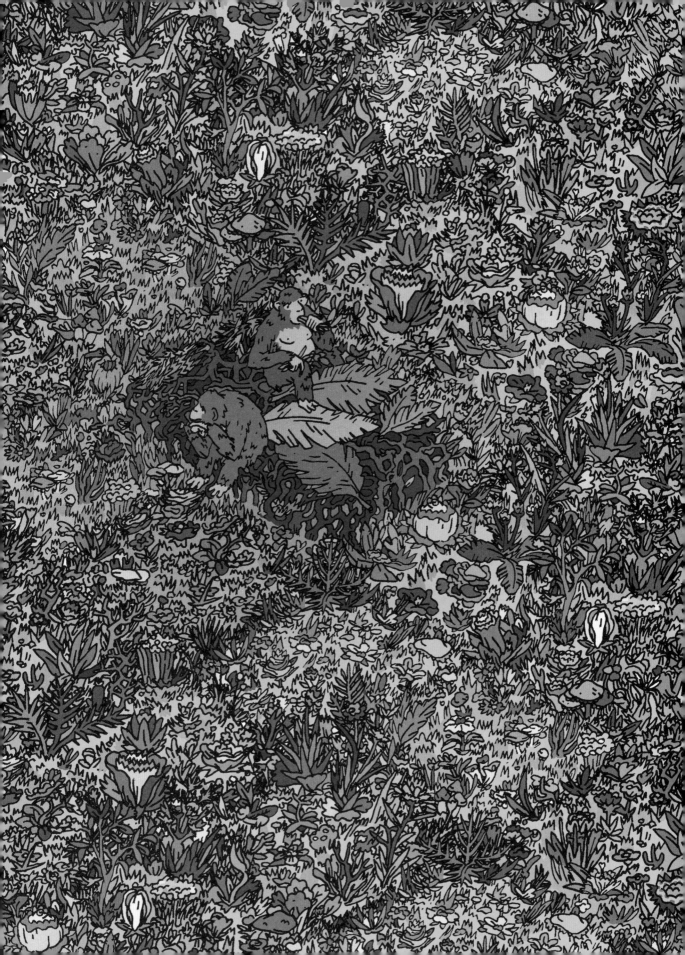

WHY DO WE AGE?

E WOULD RATHER not become more frail as we become older, and yet we do. We would prefer to continue living in full health, yet we know that we will age and that our health will eventually fail. Aging is the result of a gradual, random accumulation of a wide range of unrepaired damage and defects in our cells during the course of our lifetime, leading to a gradual loss of tissue function. Given the diversity of organisms, life histories, and ways of living that have evolved on this planet, why have we not evolved to maintain a healthy state indefinitely, barring accident, disease, or injury?

One small part of us does not age. The genetic material we inherited from our parents forms an unbroken line of ancestry connecting us back through countless generations and many billions of years to the first living organisms on Earth. Genetic information passed along this ancient chain is ageless, yet we ourselves, as the carriers of this information, are transient. Evolution is a powerful force, but it acts to guarantee the transmission of genetic material by reproduction, rather than to preserve our individual lifespans. It has shaped humans to maximize the chance of their genetic information being passed to the next generation, not to maximize the healthy lifespan of specific individuals. These two goals are not mutually exclusive, but nevertheless they are not identical.

It is conceivable that the repair and correction mechanisms within our cells could be more effective than they generally are and for these mechanisms to fend off the negative effects of aging.

One simple explanation is that organisms have simply not evolved this way because the dangerous environments in which we live and have lived are filled with external risks of dying (such as being eaten by a lion, killed in battle, or dying from disease). With limited resources, it is better for the maintenance of our long lines of ancestry to invest in reproduction as early in life as possible, rather than to invest in indefinite cellular maintenance that would be entirely wasted on the many organisms whose lives were cut short accidentally.

Evolution has simply ignored the problem of human aging, a problem of great importance to us as individuals but irrelevant to the continuing success of our species. This represents an opportunity for us to intervene usefully with medicine and science to improve our health in old age.

WRITTEN BY
CONOR LAWLESS PhD
Research Associate
Newcastle University

ILLUSTRATED BY
ATAK
www.fcatak.de

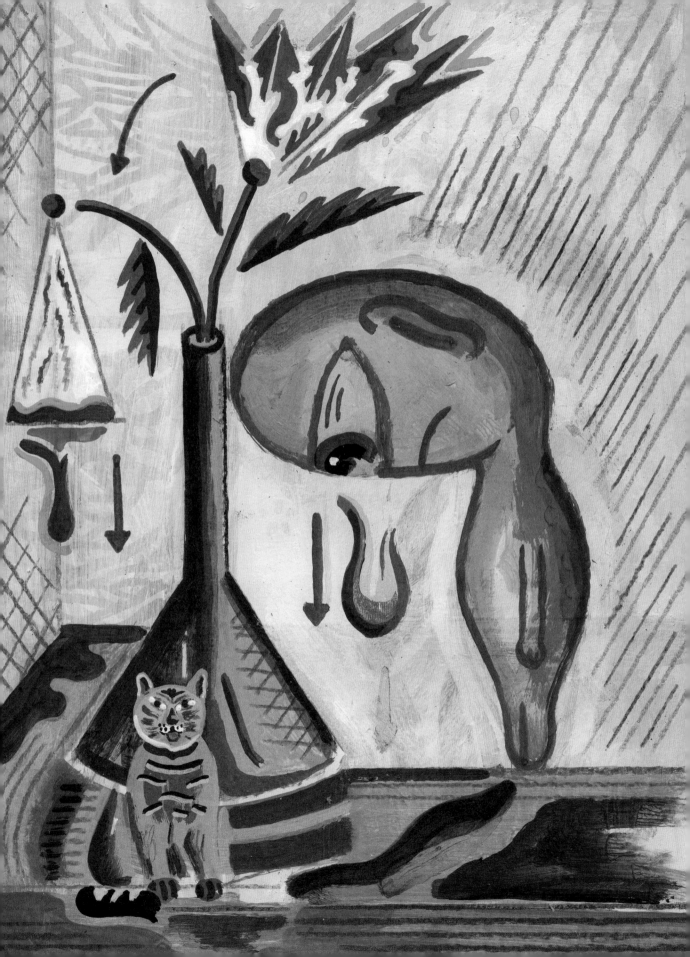

WHAT IS THE CIRCADIAN CLOCK?

O SURVIVE, LIVING THINGS must be able to adapt to changes in their environment. Fortunately, one of the most drastic fluctuations they face is also one of the most predictable: the day/night cycle caused by the rotation of the earth.

Multicellular organisms and even some bacteria track the day/night cycle using an internal timekeeping system called a circadian clock. To make fullest use of daylight, plants shift their metabolism toward photosynthesis ahead of the dawn. Some open and close leaves or flowers at specific times of day, for example. Plant movements are internally timed, not just reactions to changes in light; a heliotrope plant that opens its leaves once per day continues to do so at the correct time even when kept in constant darkness. Under unchanging illumination, animal sleep/wake cycles continue indefinitely with roughly 24-hour periodicity. However,

circadian clocks do drift gradually out of sync with the outside world in the absence of *zeitgebers* ("time givers") such as changes in light. The adaptive value of the clock in animals is not fully understood, but disruption of circadian rhythm has been linked to human pathologies such as diabetes and cancer.

Manufactured clocks are based on rhythmic oscillators; the circadian clock is no different. Instead of counting time with the swing of a pendulum or the vibration of a quartz crystal, the internal circadian clock relies on daily oscillation of protein concentrations, which is achieved via complex, internal, interlocking feedback loops. Mammalian circadian rhythms are dictated by a "master clock" located deep in the brain, but virtually every cell in the body keeps its own clock. How these trillions of individual clocks are synchronized to the master clock and what purposes they serve are still unknown.

WRITTEN BY
JOHN ERNEST KRATZ PhD

ILLUSTRATED BY
LAB PARTNERS
www.lp-sf.com

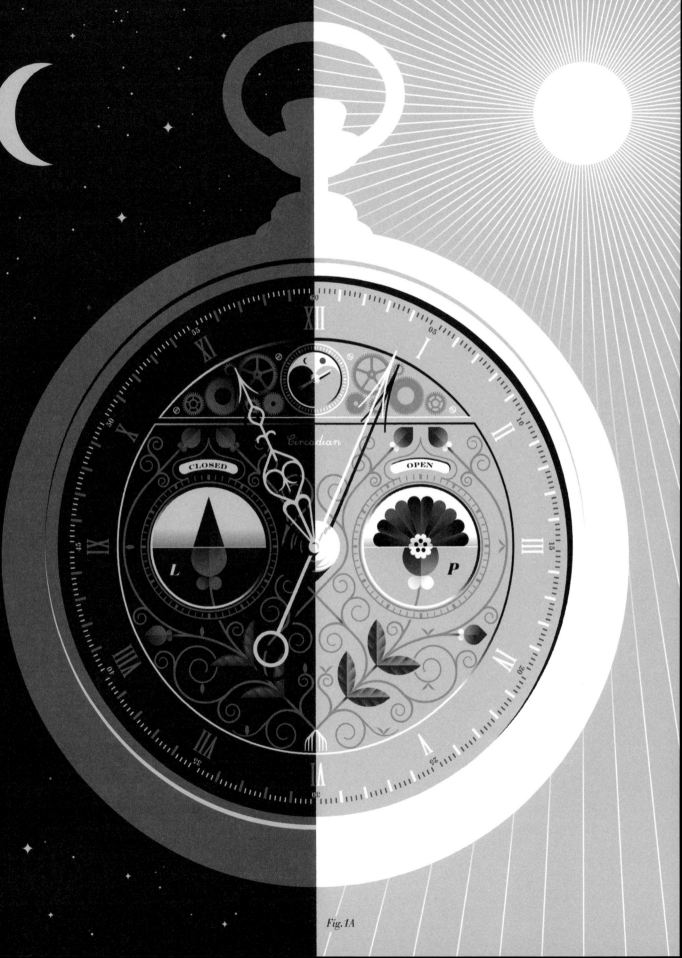

Circadian

CLOSED

L

OPEN

P

Fig. 1A

WHY DO WE SLEEP?

WHAT IS SLEEP? AS traditionally defined, an animal is judged to be asleep when it displays the following characteristics: (1) inactivity of voluntary muscles, (2) lack of responsiveness to typical external stimuli (lack of consciousness), (3) typical sleep posture (e.g., lying down), and (4) quick reversability of the unconscious state with intense stimulation. Based on these criteria, scientists have determined that all animals—mammals, birds, fish, reptiles, amphibians, and even invertebrates—sleep. The ubiquitousness of sleep across the animal kingdom suggests that it is integral to animal life as we know it. But why?

Scientists have only recently begun to piece together the answer to this question by studying what happens when animals are deprived of sleep.

At the molecular level, a phenomenon called the "unfolded protein response" occurs in a sleep-deprived animal. During sleep deprivation, proteins—the building blocks of animal tissue—begin to lose their structural integrity, or "unfold." The unfolded proteins accumulate within the animal's cells, aggregate into clumps, and become increasingly toxic. As cells become clogged up with unfolded proteins, they slowly lose their ability to perform necessary functions. If an animal is deprived of sleep indefinitely, it will die. But when an animal is finally allowed to sleep after a period of deprivation, special "cleanup" molecules help to reverse the unfolded protein response. In essence, sleep is a maintenance process during which cellular damage is both prevented and repaired.

WRITTEN BY
JOHANNA FREEMAN MS
Wildlife Biologist
Florida Fish and Wildlife Commission

ILLUSTRATED BY
CAMILLA ENGMAN
www.camillaengman.com

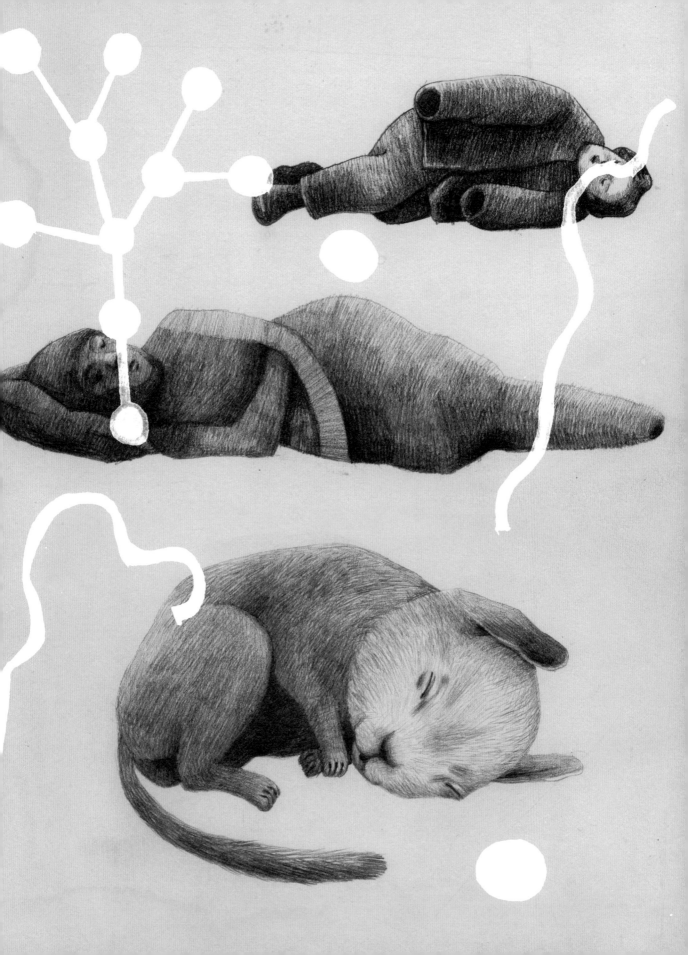

WHY DO WE DREAM?

 REAMS ARE STRANGE things—emotionally charged, intensely vivid parts of our nighttime lives in which the rules of the waking world seem not to apply. Most dreams occur during a critical stage of sleep called REM (rapid eye movement). During REM, the brain's activity is very similar to the waking state. But even as neurons fire away, signals to the spinal cord are suppressed, keeping the body mostly paralyzed.

Science continues to uncover what happens during REM sleep, but why we dream remains a mystery engaging scientists across disciplines. Early psychological theories of dreams emphasized unconscious conflict—dreams as places to act out repressed impulses or forbidden desires through symbolic representations. Contemporary research suggests that dreams may serve functions important to our evolutionary success, like integrating the day's new memories into long-term storage or giving us the chance to practice responding to simulated threats without any actual risk to safety.

Another prominent theory is that dreams emerge from the mind's constant need to process and interpret sensory information, as it does during the day. Breakthroughs in neuroimaging technology have revealed that whereas visual and motor areas are active during dreams, the brain's reasoning center (the prefrontal cortex) is less activated. As signals flash randomly throughout the visual areas, the prefrontal cortex may be struggling to impose order on this chaotic sensory information, perhaps explaining why during a dream it somehow "makes sense" that we are walking through a forest at one moment and a city the next. Our scientific understanding of dreams and their functions is far from complete, but it may be that the mind's attempt to interpret random firings within the brain—without the benefit of logical reasoning—is what allows us, at night, to defy the laws of gravity and fly.

WRITTEN BY
BRETT MARROQUÍN MA, MS, MPhil
PhD Candidate
Yale University

ILLUSTRATED BY
JOOHEE YOON
www.jooheeyoon.com

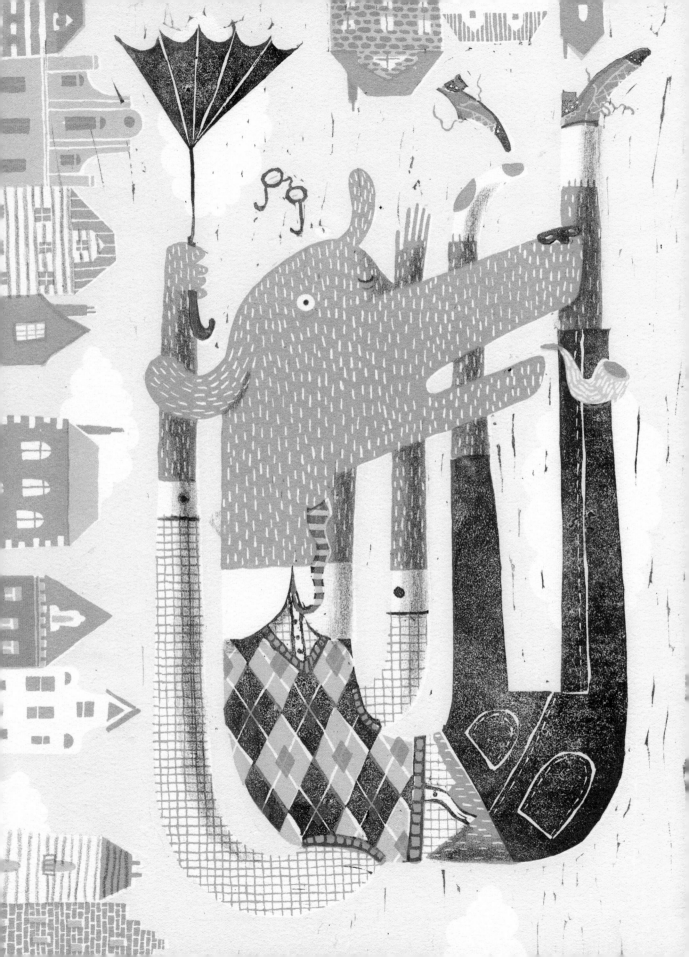

WHY DO WE YAWN?

YAWNING IS A UBIQUITOUS human behavior, and its role has been subject to centuries of speculation, superstition, and social custom. Despite its commonness, the precise effects of yawning are still largely mysterious and are actually hotly disputed among leading yawning researchers. Many hypotheses for a physiological role in yawning have been tested, such as increasing brain oxygen, arousal, pressure release in the middle ear, and cooling of the brain. The thermal regulation hypothesis has gained some support recently, though this remains controversial. There is either a dearth of evidence or negative evidence for other physiological effects of yawning.

While the effects of yawning are speculative, the triggers for yawning are more clearly defined.

Drowsiness is a common trigger for yawning, but surprisingly, the most frequent trigger for yawning is social contagion. Yawning is contagious in humans, and it seems to rely on the social interaction skills of the yawning individual. Infectious yawning has been observed in only a few animal species, including chimpanzees and, possibly, dogs. In humans, spontaneous yawning has been observed in utero, but contagious yawning cannot be reliably induced in children before the age of five or in individuals with disorders affecting social interaction, such as schizophrenia and autism. Scientists believe that the susceptibility to contagious yawning is related to the empathic ability of the individual, and in support of this view, they have mapped yawning to regions of the brain involved in empathy and social behavior.

Perhaps another answer to the question "why do we yawn?" is: I yawn because I care.

WRITTEN BY
REBECCA C. BURGESS PhD
Postdoctoral Fellow
National Institutes of Health

ILLUSTRATED BY
NOLAN HENDRICKSON
www.nolanhendrickson.com

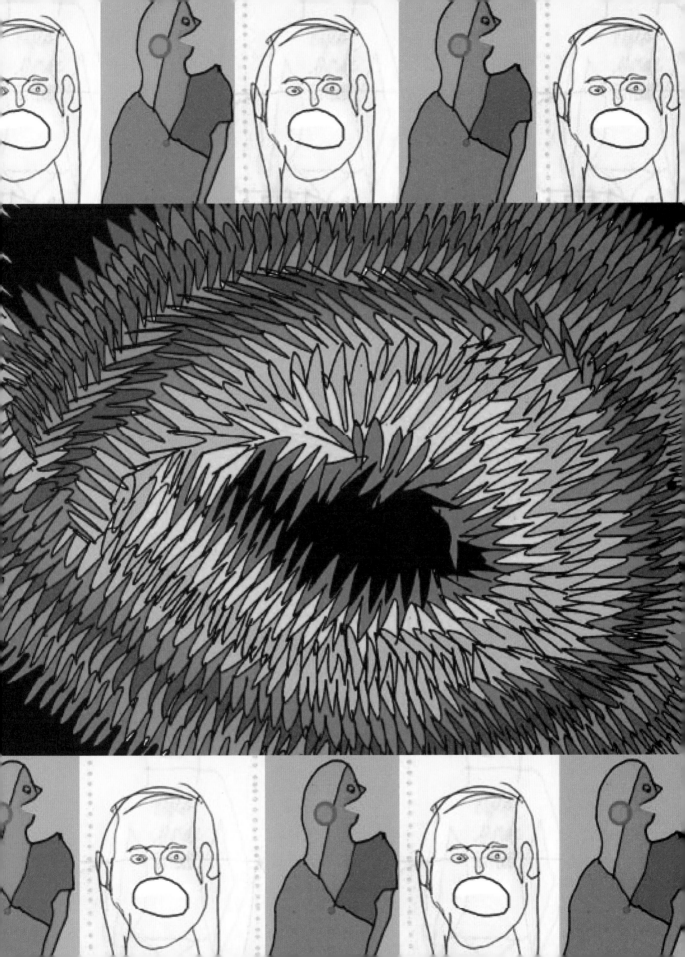

WHY DO WE HICCUP?

HOLD YOUR BREATH FOR ten seconds. Try drinking water from the wrong side of the glass. Have someone scare you. Press on your eyeballs. Chances are, someone suggested one of these folk remedies to you the last time you had the hiccups. There are many tricks to quell hiccups, but why do we hiccup in the first place? Hiccups happen when our diaphragm, the muscle in our chest that controls breathing, spasms involuntarily, causing a sudden rush of air into our lungs. Our vocal cords shut to stem the flow of air, thus producing the sound of a hiccup. No one knows exactly what triggers the diaphragm to spasm, although it's probably due to stimulation of the nerves connected to the muscle or to a signal from the part of the brain that controls breathing.

Some scientists hypothesize that the neural circuitry implicated in human hiccuping is an evolutionary vestige from our amphibian ancestors who use a similar action to aid respiration with gills during their tadpole stage. Humans have maintained the neural hardware, scientists theorize, because it may benefit suckling infants who must manage the rhythm of breathing and feeding simultaneously.

Harmless, everyday events that can provoke hiccups include drinking carbonated beverages, eating spicy foods, and accidentally swallowing air. More serious and less common events include respiratory illnesses, abdominal disorders, and even brain tumors. Apparently, increasing the amount of carbon dioxide in our blood helps suppress hiccups, which is why we're often told to hold our breath or breathe into a bag when we get them. But then again, research also indicates that oral ingestion of sugar is an effective treatment for hiccups. So next time you get them, will you reach for a paper bag . . . or a spoonful of sugar?

WRITTEN BY
JILL CONTE MA

ILLUSTRATED BY
DAVE ZACKIN
www.davezackin.com

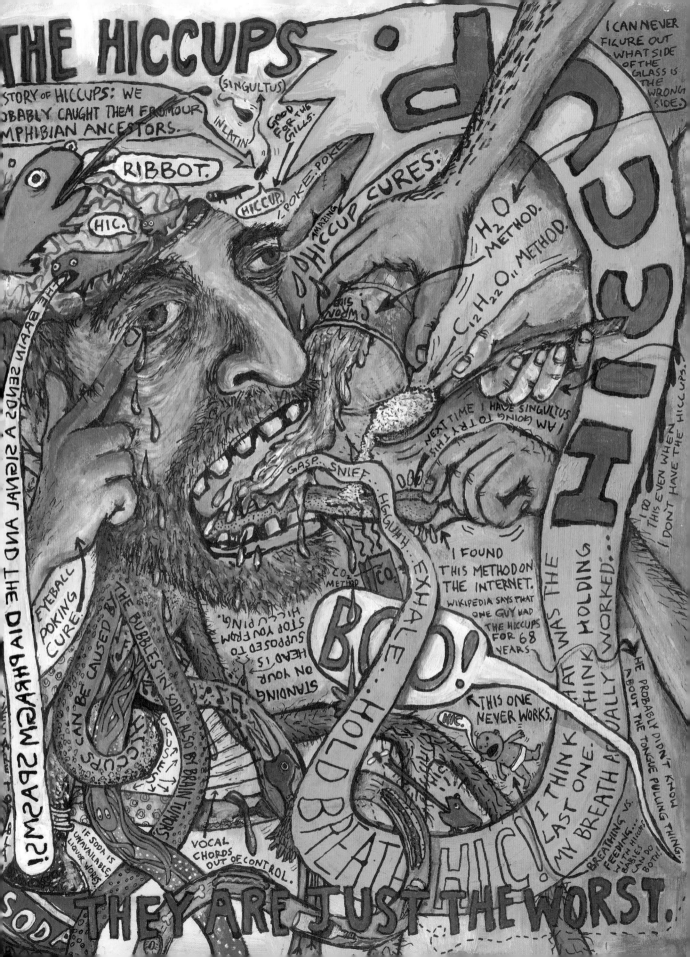

WHY DO WE BLUSH?

LUSHING IS A FAIRLY COM-
mon, universal human
experience. And yet, no one
really knows why or how
it happens. Blushing is characterized
by an involuntary and uncontrollable
reddening or darkening of the skin due
to increased blood flow near the surface
of what's called the "blush region": the
face, ears, neck, and occasionally the
upper chest.

Blushing, unlike the similar phenom-
enon "flushing" that occurs all over
the body, is an emotional response
often associated with the social experi-
ence of embarrassment, shame, self-
consciousness, or attention. The ruddy
or darkened hue of a blush occurs when
muscles in the walls of blood vessels
within the skin relax and allow more
blood to flow. Interestingly, the skin of
the blush region contains more blood
vessels than do other parts of the body.
These vessels are also larger and closer
to the surface, which indicates a pos-
sible relationship among physiology,
emotion, and social communication.
While it is known that blood flow to
the skin, which serves to feed cells and
regulate surface body temperature, is

controlled by the sympathetic nervous
system, the exact mechanism by which
this process is activated specifically
to produce a blush remains unknown.
And yet, theories abound as to why
we blush.

While some think that blushing is
merely an expression with no function
in and of itself, others think it may be a
form of nonverbal communication that
signals both a recognition of and an
apology for the breech of a social norm.
Psychoanalysts theorize that blushing is
the physical manifestation of repressed
exhibitionism that draws attention to
a person. Others believe that blushing
signals submission, especially when
accompanied by related mannerisms
such as an averted gaze and nervous
smile, to assuage potential aggression
directed at a person. Alternatively,
blushing may be a rebound effect of
blood returning from the muscles after
an aborted flight response. Or it may be
that we blush because we're anxious
about, well, blushing; self-awareness
that one is blushing can create a feed-
back loop that actually intensifies it.
With all this talk about blushing, are
you blushing yet?

WRITTEN BY
JILL CONTE MA

ILLUSTRATED BY
GILBERT FORD
www.gilbertford.com

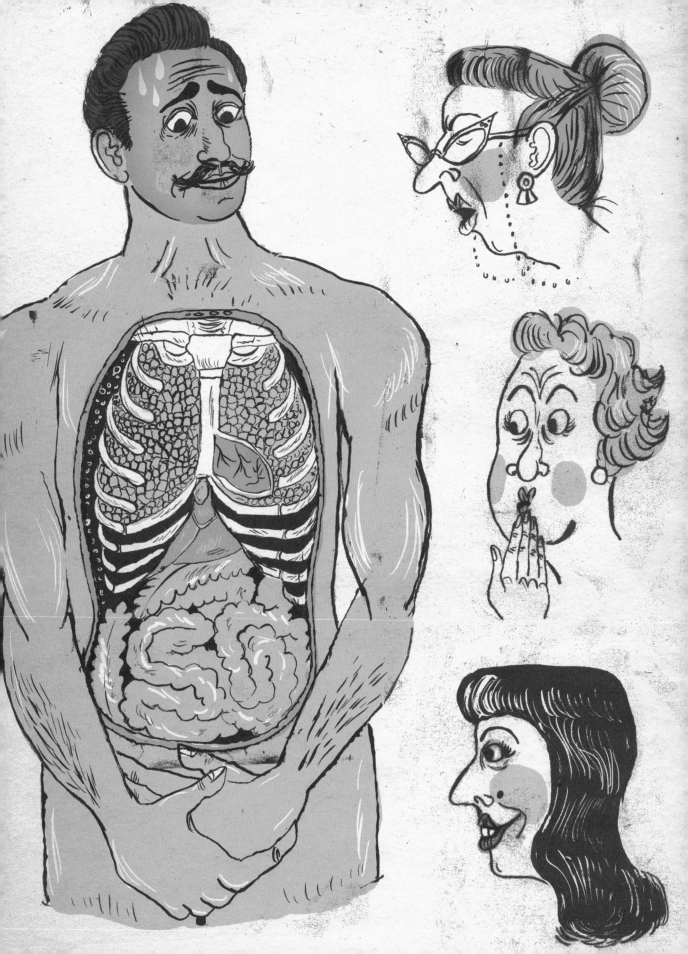

WHAT CAUSES DEPRESSION?

VERYONE EXPERIENCES sadness and grief, but not everyone experiences clinical depression, which comes not only with extreme sadness, but also with changes in sleep and appetite, difficulty concentrating, physical slowing or agitation, and an inability to experience pleasure. Depression is one of the most researched disorders in modern clinical science, but still its causes are not fully understood.

Early psychological theories of depression replaced pre-scientific theories based on demons or imbalanced "humors" by emphasizing unconscious conflicts that give rise to neuroses. In the last half-century, scientists have focused on behavioral, cognitive, and biological causes of the disease. Behavioral research in animals and humans indicates that the individual's actions and the environment's responses (for example, rewarding or punishing) can lead to depression through basic learning mechanisms. Cognitive studies show that differences in the information people attend to in the world—and how they then process that information—can determine whether or not stimuli end up fueling depression. And biological research reveals that depression is linked to dysfunction in neurotransmitters, the chemicals that allow neurons to communicate. These are the targets of most modern pharmacological therapies for depression.

Despite remarkable progress in understanding the science of depression, it seems that all of these factors are interrelated in ways not yet understood. Certain genes have been linked to depression (most because they control neurotransmitters), but they appear to cause depression only in combination with early life stress. In fact, stress itself seems to alter brain anatomy through hormonal mechanisms, shrinking neural structures that are important in cognition and depression and even through turning genes "on" or "off." The current frontier of the science of depression takes an interdisciplinary "biopsychosocial" approach. It appears that genetic, neurochemical, psychological, and environmental factors all influence each other, suggesting a very complex picture of depression that science is only beginning to understand.

WRITTEN BY
BRETT MARROQUÍN MA, MS, MPhil
PhD Candidate
Yale University

ILLUSTRATED BY
MAXWELL HOLYOKE-HIRSCH
www.lorenholyoke.com

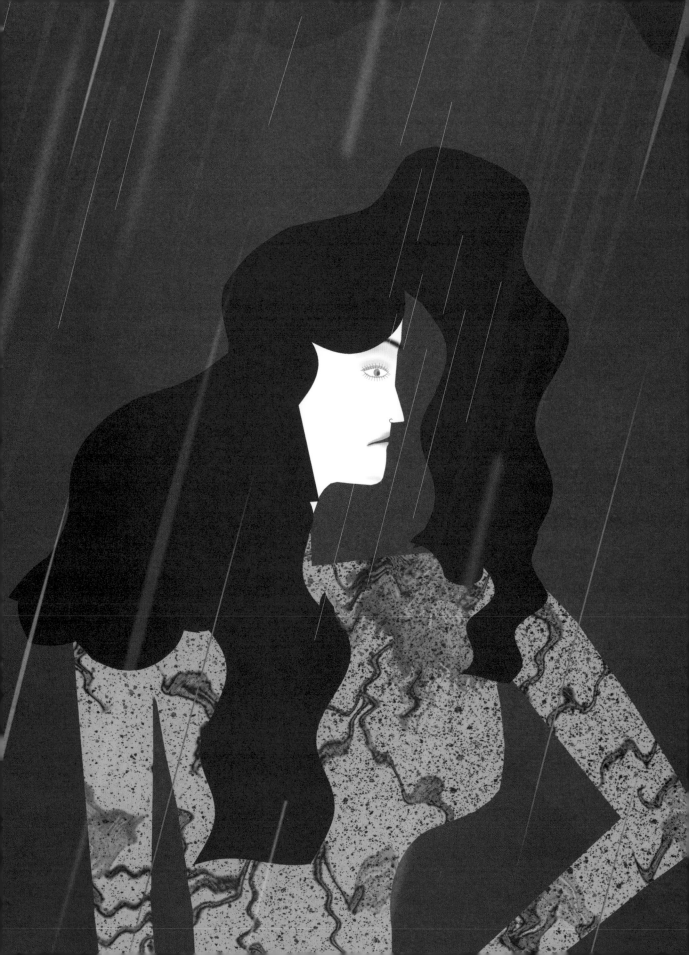

WHAT CAUSES AUTISM?

AUTISM IS AN UMBRELLA term for a group of pervasive developmental disorders that affect the development of many systems. Notable differences found in the autistic population include communication and socialization delays, restricted interests, and difficulties processing sensory information. The incidence of autism is estimated to be around one in every 110 live births, with tens of millions of individuals affected worldwide. Experts believe that autism is on the rise, however, the causes of the disorder are still unknown.

There is general agreement in the scientific community that there is a genetic component to autism—children who have a parent or sibling with autism have a higher risk of having autism themselves. However, genetics alone cannot explain why autism occurs. A common belief is that autism is the result of an interaction between genetic and environmental components. Environmental risk factors that have been linked to autism include pesticides, viruses, chemicals in household products, stabilizers in certain immunizations, low oxygen during delivery, maternal use of certain medicines, and environmental pollutants. (This is a sampling of just some of the many environmental factors discussed in autism research, and many of them are highly controversial.) However, just as autism is a heterogeneous disorder that can present with a wide range of symptoms and severities, experts agree that there is no single cause of autism.

There is an expression that says that if you've met one person with autism, you've met one person with autism. One could apply this to the etiology of the disorder: If you've discovered one cause of autism, you've discovered one cause of autism.

WRITTEN BY
JESSIE STRAUSS MS, OTR/L
New York City Department of Education

ILLUSTRATED BY
SOPHIA MARTINECK
www.martineck.com

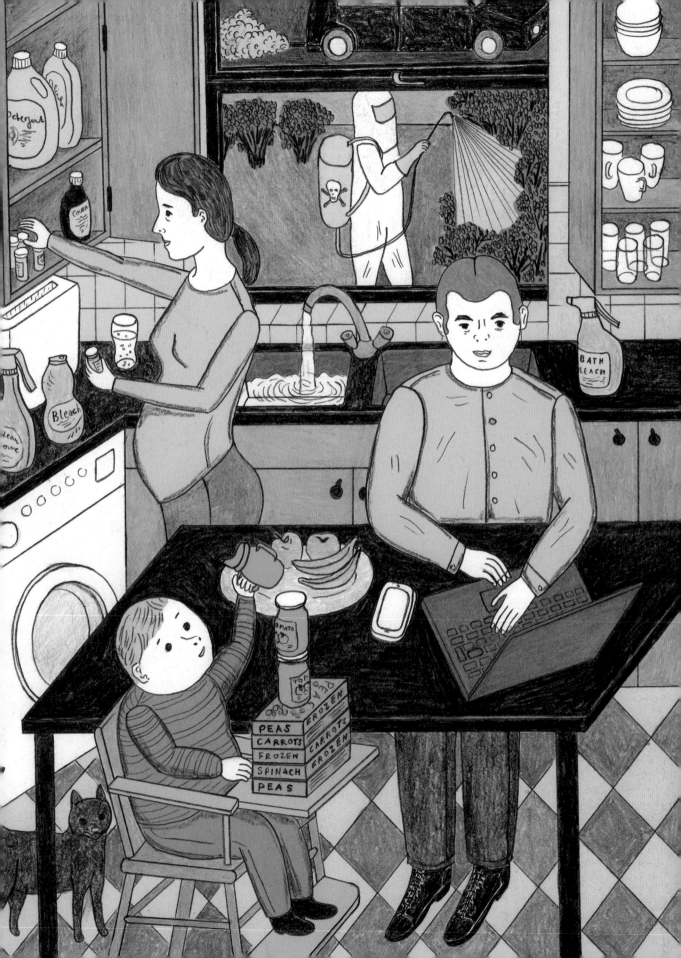

WHY DO PLACEBOS WORK?

PLACEBOS BAFFLE SCIENtists. These harmless pills, medicines, or procedures are prescribed more for the psychological benefit to the patient than for any physiological effect or are used as controls in testing new drugs. There is no reason why placebos should work, and yet, they often do. The explanations all center on the idea of "mind over matter."

The predominant explanation for the placebo effect is that the patient expects the placebo to work, which leads to changes in brain activity, chemistry, or both. Support for this idea comes from a study showing that patients who were unwittingly given effective pain medication experienced fewer benefits than they did when they expected a benefit but were given a placebo.

It is important to note, however, that placebos do not work on disease-causing agents, but instead are effective only on conditions in which the brain plays an important role. For example, placebos do not produce significant results in curing cancer or the flu, but they have had remarkable success in treating depression, pain, and weight gain. This indicates that the brain is playing an essential role in the patient's recovery.

Until we have a better understanding of the placebo effect, the best answer to the question of why placebos work is because we want them to.

WRITTEN BY
SARA FOX PhD
Biology and Forensic Science Teacher
Cypress Fairbanks Independent School District

ILLUSTRATED BY
PENELOPE DULLAGHAN
www.penelopedullaghan.com

WHAT TRIGGERS PUBERTY?

PUBERTY: ONE OF THE MOST embarrassing life stages that humans undergo. Voice changes, hair in comical new places, the ravages of acne, and a new reliance on deodorant all typify the stage, leaving no one safe from puberty's humiliating path. But what triggers puberty—the transition from a child to an adult capable of reproduction? In order for the pubertal misery to begin, the hormone GnRH (gonad-atropin releasing hormone) must begin pulsating from the brain's hypothalamus, which it does at about age 10 in girls and age 12 in boys. GnRH sets in motion a hormonal cascade, resulting in growth spurts, body hair, and secondary sex characteristics (for the lucky ones!).

What is unclear is what causes these pulses of GnRH to wreak their havoc to begin with. Genetics probably play roughly half the role in the timing of the release of GnRH. Diet accounts for some differences in pubertal onset; for instance, malnourished children tend to develop later. Inadequate diet could also be linked to a lack of the hormone leptin, which is released by adipose (fat) tissue and may instigate puberty. Race and ethnic differences appear to contribute to the age of onset as well. Even altitude is thought to have an impact. Some fear that environmental pollutants such as bisphenol A from plastics or estrogen in drinking water may also set the wheels in motion, possibly earlier than they would otherwise. Perhaps most interesting of all are the social factors—stress and home environment contribute. For example, girls born in households with a present biological father tend to have a later menarche. Consequently, it remains unclear exactly what (or maybe who!) is to blame for the timing of puberty.

WRITTEN BY
ELLEN SMITH LT, NP-C, WHNP-BC
Nurse Practitioner
U.S. Public Health Service Commissioned Corps

ILLUSTRATED BY
VANESSA DAVIS
www.spanielrage.com

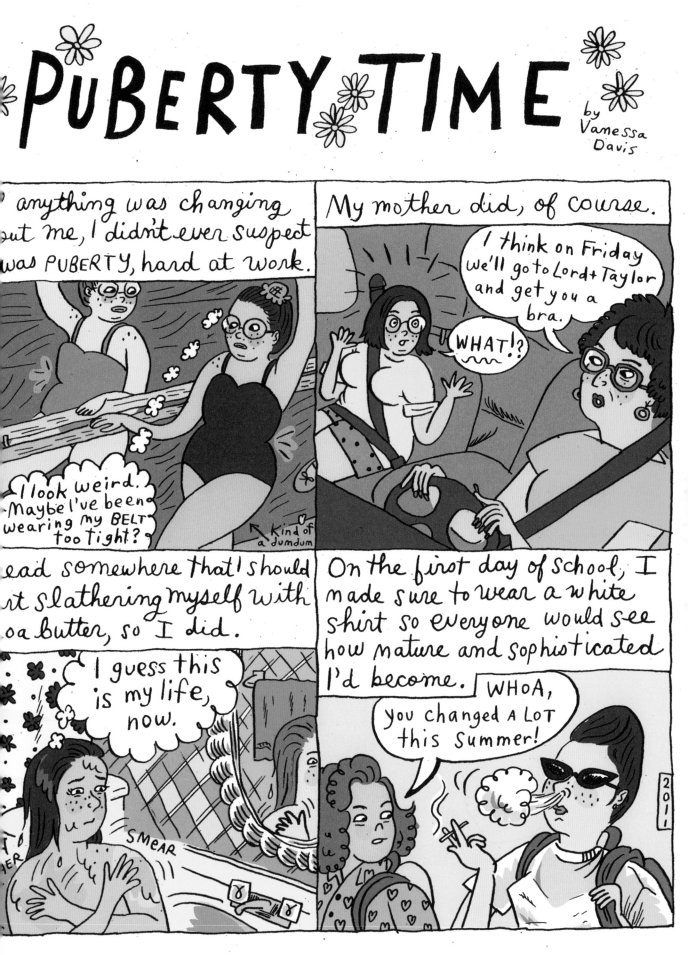

DO HUMANS USE PHEROMONES?

O HUMANS USE PHERO- mones? The jury is still out. Many organisms do use scent as a form of silent communication. Some mammals use scent to signal their desire to mate and to seek out a suitable partner, and insects have been known to use chemical signals as an alarm to warn other bugs that a predator is near. Some plants have even been found to release scent signals in response to physical trauma—which causes neighboring plants to produce bitter compounds that could potentially make them less appetizing to a hungry herbivore.

Most studies on mammal pheromones examine the rodent olfactory system. Mice have two separate olfactory regions in their noses. They have a regular olfactory system much like ours, which they use to help them locate food, and they also have a separate anatomic region within their nasal cavity called the vomeronaso organ, which is used to detect the pheromones that help determine their mating behavior.

We know that if we as humans lose our olfactory bulb, we lose our ability to smell and for the most part to taste our food, since most of our taste perception is actually based on scent. But what happens when mice lose their vomeronaso organs?

In a 2007 study, Catherine Dulac, a molecular neurobiologist at Harvard University, observed that ablating the vomeronaso organ in mice changed their sex-specific behaviors. Male mice lacking channels in their vomeronaso organs had impaired sex discrimination and a reduction in male on male aggression. The results in female mice were even more impressive. "Strikingly, mutant females display unique characteristics of male sexual and courtship behaviours such as mounting, pelvic thrust, solicitation, anogenital olfactory investigation, and emission of complex ultrasonic vocalizations towards male and female conspecific mice." Instead of assuming a sexually receptive lordosis position, the females would mount any other mouse, male or female, within reach.

To this day, no structure resembling the vomeronaso organ has been found in humans, but there is evidence that our sexual behaviors and even reproductive capacity can be affected by scent, and unsurprisingly, there are plenty of products seeking to capitalize on this ability. Despite impressive ad campaigns for products that purport to contain pheromones, we have yet to see the same kinds of scent-mediated sexual behavior changes in humans that Dulac saw in mice. Humans rely on a great many higher order signals to mediate our sexual behavior—from conversation over coffee to fancy underwear. But who knows? In a few years, a new sexual revolution may be a sniff away.

WRITTEN BY
ABIGAIL COHEN
Drexel University College of Medicine

ILLUSTRATED BY
MARK MULRONEY
www.markmulroney.com

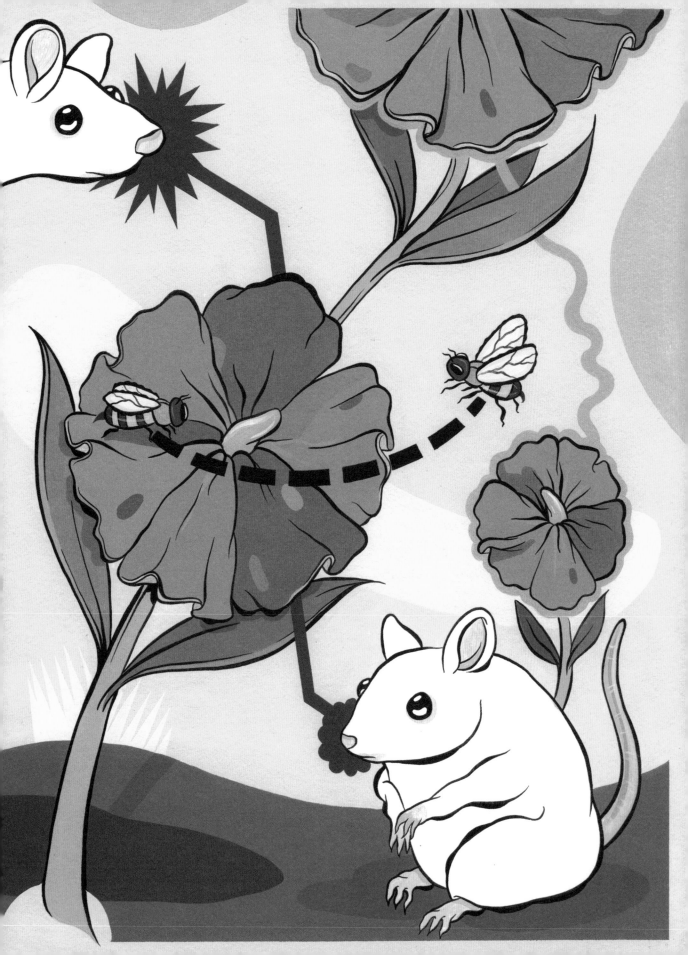

IS SEXUAL ORIENTATION INNATE?

DIVERSITY IN SEXUAL attraction and behavior, including same-sex orientation, has been documented throughout human history and appears in nonhuman species as well. The discussion of whether sexual orientation is innate or socially developed has a long history, and it remains an open—and controversial— scientific question.

Evidence that sexual orientation has a genetic component comes from studies of twins. Siblings of homosexual individuals are much more likely to be homosexual if they are identical twins (who share 100 percent of their genes) than if they are fraternal twins or non-twin siblings (who share 50 percent of their genes). But from an evolutionary perspective, homosexual behavior seems to be a paradox: How can natural selection allow for the passing on of genes favoring non-procreative sexual

behavior? A prominent explanation, called "kin selection," is the hypothesis that by procreating less often themselves, homosexual individuals are able to help provide for nieces and nephews—with whom they share genes— thus improving the chances their own genes will be passed on. Another theory suggests that genes contributing to homosexual orientation in men also contribute to greater fertility in women, increasing the overall reproduction of the genes over the long term of the family line.

Some scientists argue that other biological differences between homosexual and heterosexual individuals are signs of "innate" factors. For example, some studies show that particular brain structures differ between homosexual and heterosexual men. (There is less evidence of this among women.) Even if such biological findings are well replicated, however, they do not necessarily

mean sexual orientation is innate. For instance, some evidence suggests that the differences in brain anatomy are influenced by the levels of sex hormones during prenatal development.

Genetic factors could also be influencing more general characteristics (for instance, physiological arousal levels) that happen to contribute to, among other things, homosexual or heterosexual orientation over the course of an individual's development. The scientific investigation of sexual orientation is controversial and at an early stage, but scientists increasingly suspect that, like much other social behavior, sexual orientation is a product of both innate and environmental influences. Whether or not a straightforward "gay gene" is identified, much work remains for both biological and social scientists before the controversy will be resolved.

WRITTEN BY
BRETT MARROQUÍN MA, MS, MPhil
PhD Candidate
Yale University

ILLUSTRATED BY
EDIE FAKE
www.ediefake.com

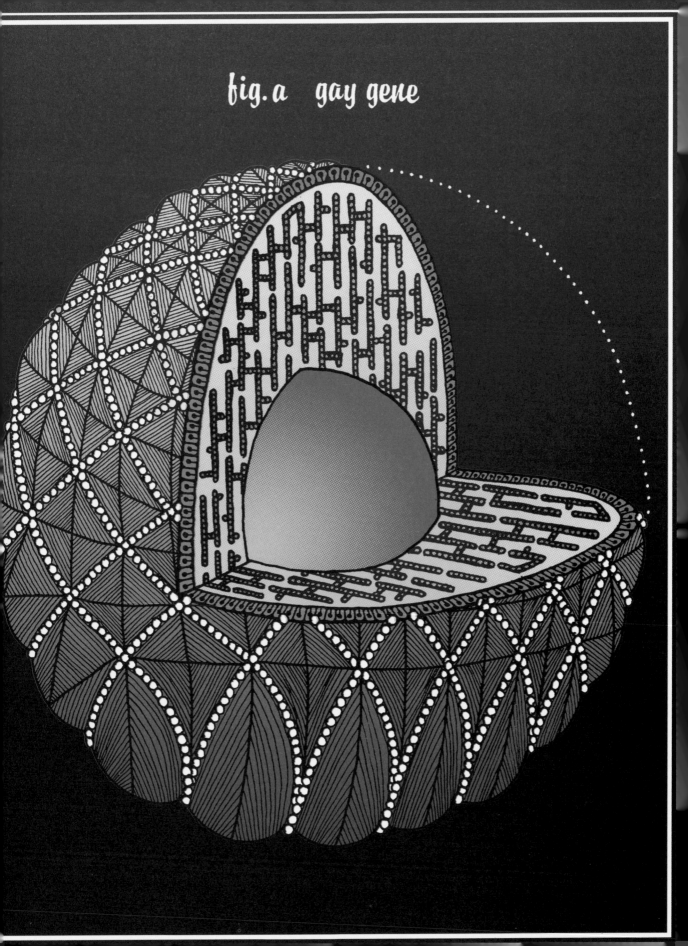

fig. a gay gene

WHY DO WE HAVE AN APPENDIX?

SCIENTISTS DO NOT AGREE on the evolutionary origin of the human appendix or its function, but there are several theories about why humans have an appendix and what it does. The appendix may be a vestigial organ, a remnant of a larger cecum (a pouch in the large intestine) used to digest plant fiber when human ancestors had a more plant-based than carnivorous diet. This theory rests on the fact that many modern herbivores have large ceca.

Some think that the appendix in modern humans has no function, while others think that it harbors microorganisms beneficial to the large intestine. When digestive problems such as diarrhea disrupt the large-intestinal microflora, the large intestine can be repopulated from the organisms in the appendix. The appendix may also contribute to the immune system because it contains a large amount of lymphoid tissue, which is associated with the lymphatic system, an important part of the immune system. However, the immune role of the appendix is unknown.

Scientists are researching the origin and function of the appendix by studying the characteristics and composition of the appendices of humans and many different nonhuman primates.

WRITTEN BY
HELEN A. MARKEWICH PhD

ILLUSTRATED BY
PATRICK KYLE
www.patrickkyle.com

WHY DO WE HAVE FINGERPRINTS?

I'S BEEN COMMONLY ACCEPTED for years that fingerprints evolved out of the need to improve our grip on surfaces, especially for climbing applications. This is why we share the trait with most primates and other arboreal and aquatic mammals. The belief stems from the fact that textured or rough surfaces typically exhibit greater friction than smooth surfaces, which makes rough surfaces easier to grasp. However, this common explanation is now under fire, as recent studies have shown that, depending on the pressure applied, the contact area applied to a dry surface is smaller for rough sensors (fingerprints) than smooth sensors (no fingerprints), resulting in decreased friction. This controversial result comes with the implication that fingerprints do not in fact help us grip under certain conditions.

What is certain is that fingerprints aid in gripping wet surfaces. The grooves of the print provide a channel for water to escape from between the finger and the surface, eliminating the slippery water film. This wet-surface theory has been extended to explain why our digits become wrinkled when they are exposed to an excess of water: The deepening of the grooves increases the drainage network.

Fingerprints are also integral to our ability to sense texture. When a sensor covered with a rough exterior (fingerprint) is run over a surface, significantly more vibrations are generated than when a sensor covered with a smooth material (no fingerprint) is sliding against that same surface. Since the high surface area of our fingertips allows for a high concentration of Pacinian corpuscles, nerve endings responsible for sensing pressure and vibration, we are able to detect subtle changes in texture due to monitoring the change in vibration as we run our fingers across a surface.

WRITTEN BY

DREW WRIGHT MS
Research Librarian
Weill Cornell Medical College

ILLUSTRATED BY

NORA KRUG
www.nora-krug.com

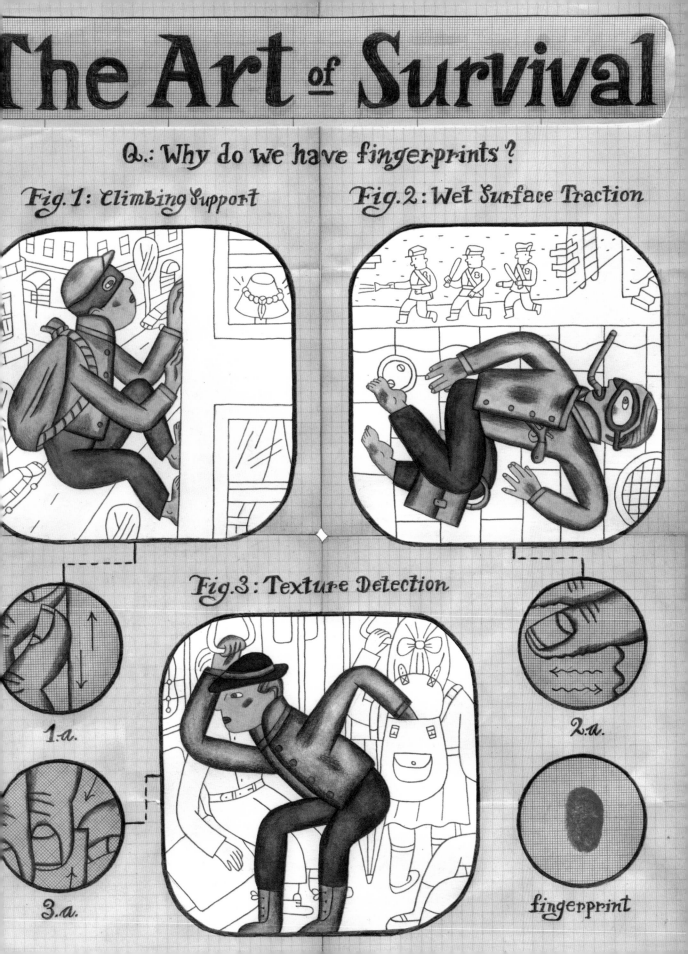

HOW DO HUMANS HAVE THE ABILITY TO LEARN LANGUAGE?

ESPITE THE FACT THAT many animals are able to communicate, humans are the only species known to have language. Given the right conditions, every person exposed to a language during the critical period of language development—from birth to about eight years old—will learn that language. First, children learn the smallest parts of language, the phonemes, such as the "puh," "buh," and other sounds that make up a language. Then, they learn morphemes, the building blocks of words that contain meaning, such as the "un" in *unhappy*. Eventually, they learn how to fit all those features together to form words, phrases, and sentences. And beyond verbal and written language, humans are also able to create and learn signed languages, which have their own grammar.

But *how* do humans have the ability to learn language? One of the earliest theories—developed by linguists such as Noam Chomsky—posits that a universal grammar underlies every language and that humans have evolved the innate capacity to learn language. In other words, although languages may seem different, there is something fundamentally similar in all of them, and language learning is innate to humans. But so far nobody has been able to prove the existence of universal grammar, and the theory is the source of much debate in the linguistic community. Some linguists believe that humans do not have an innate capacity for language and that they learn language merely by imitating what they hear and see. Other linguists give humans more credit, suggesting that instead of imitating others, each person analyzes the language he or she hears and decides what the rules of grammar are.

Researchers constantly learn more about language by studying both people who are learning languages and those with communication disorders. It seems that the question of how humans learn language may never be answered, but as long as we have language, we will be able to argue about it.

WRITTEN BY
LIZA TRINKLE MEd

ILLUSTRATED BY
JEREMYVILLE
www.jeremyville.com

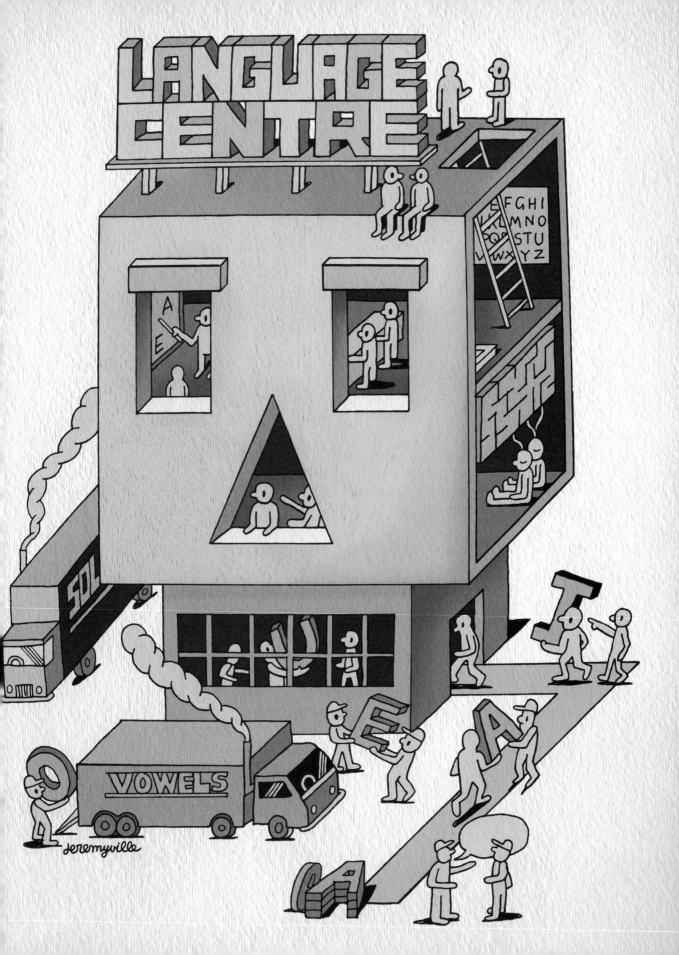

DO TREES TALK TO EACH OTHER?

TREES DO NOT TALK WITH words or writing, and their communication is probably not as engaging as a long talk with your best friend, but they are able to send each other messages that help their day-to-day survival. Many forms of tree communication have been known for a long time and don't require complicated explanations: When one tree grows a little faster and higher than its neighbors, it's telling them to either "grow up" or "grow out." You can see that the neighboring trees hear and understand this communication: In order to gain access to light, they branch out laterally from the shade of the taller tree or send branches up higher, trying to get above the tall tree's influence.

Other trees communicate with less subtle and more sinister tactics. The tamarisk or salt cedar, which is invasive in North America, absorbs salt from soil and water sources and deposits it into its foliage and, ultimately, the topsoil surrounding the plant. This process leads to high salt concentrations in topsoil. The tamarisk tolerates this salty topsoil, but most other plants cannot, which leads to a decrease in local plant species diversity. In creating this salty environment, the tamarisk tree has communicated that its neighborhood is available only to members of its own kind.

A different, more cooperative form of communication has been observed in members of the sage family. A recent study documented that when individual sagebrush plants were subjected to herbivore stress, they produced secondary compounds that rendered their leaves less palatable to grazing insects. What is even more exciting is that when neighboring plants of the same species were exposed to the same secondary compounds, they experienced less leaf damage than did unexposed plants. This research suggests that the plants were warning each other of impending danger. Based on the complexity of recently identified plant communication systems, it seems almost inevitable that there are many more ways that trees talk with each other.

WRITTEN BY
NOAH GREENBERG
Wetland Scientist and Ecologist
Wright Water Engineers Inc.

ILLUSTRATED BY
LILLI CARRÉ
www.lillicarre.com

HOW LONG CAN TREES LIVE?

MAJESTIC TREE OFTEN prompts us to wonder: How long has that tree been standing sentry over this place? The answer may be astonishingly long. In the White Mountains of California, bristlecone pines more than 4,800 years old definitely look the part, with gnarled and contorted trunks. What is the secret to their longevity? First, the cool and dry climate prevents fungi from attacking and weakening the trees, and second, bristlecone wood is dense and highly resinous and is an effective defense against pathogens. Equally impressive but greater in size, giant sequoias reach ages in excess of 3,200 years. Favorable climatic conditions and durable wood and bark that protect the trees from pests and fire are linked to the trees' longevity.

But there is another kind of longevity. What if a tree could clone itself, sprouting new stems from the roots when the trunk is killed? Unlike the giant sequoias and bristlecones, each of which is genetically unique, a stand of thousands of aspen trees may be a single organism. Scientists have estimated the age of a giant clonal colony of aspen named "Pando" (Latin for "I spread") to be upward of 80,000 years old. Although some researchers believe that clones deteriorate with age, some suggest that the colony could perpetuate itself forever under the right conditions.

WRITTEN BY
CHARLES A. NOCK PhD
Postdoctoral fellow
Université du Québec à Montréal

ILLUSTRATED BY
BECCA STADTLANDER
www.beccastadtlander.com

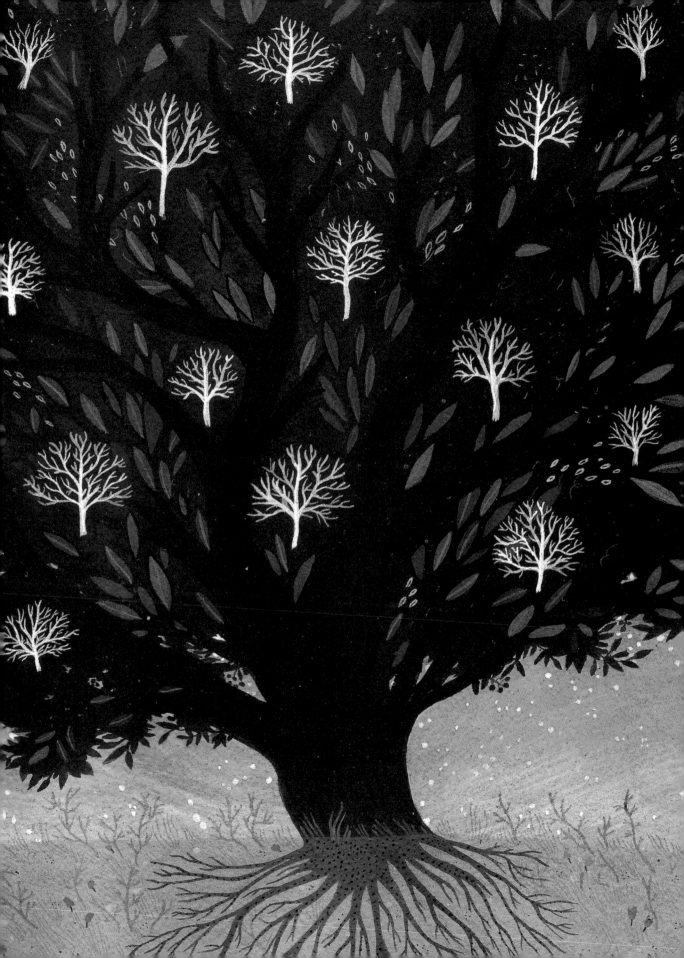

QUESTION / 51

WHY DO SOME PLANTS EAT ANIMALS?

E USUALLY IMAGINE plants to be peaceful, quiet organisms thriving on water, sunlight, and the occasional sprinkling of fertilizer. We may think of them as sources of food, or clothing, or simple decoration. Some plants are less cooperative, however, having developed complicated strategies for the capture and digestion of protozoa, insects, and even small invertebrates. These mechanisms can be passive, like the sticky or slippery appendages of the sun dew and pitcher plants, or as active as the snapping shut of the Venus flytrap and waterwheel plants. In fact, while carnivory is certainly an unusual trait in plants, it is far from a trivially rare adaptation, and has evolved independently in several plant lineages. How and why these different kinds of carnivorous plant species developed a similar taste for "more advanced" organisms remains a mystery.

Because many carnivorous plants are found in bogs and marshes, one theory is that they were forced to develop these kinds of coping mechanisms in the face of low-nutrient, swampy environments that are inhospitable to photosynthesis. We don't know precisely how gradual evolutionary change led to this adaptation, though. What kind of leaf-tip mutation would have conferred sufficient advantage, such that the vacuum trap of the bladderworts could have begun to develop? And how did the necessary digestive juices and metabolic processes for carnivory happen to arise at the same time? Suffice it to say, some plants have bucked their traditional reputation as harmless food, instead taking on a more predatory role.

112

WRITTEN BY
MARGARET SMITH MA, MSLIS
Physical Sciences Librarian
New York University

ILLUSTRATED BY
JIM STOTEN
www.jimtheillustrator.co.uk

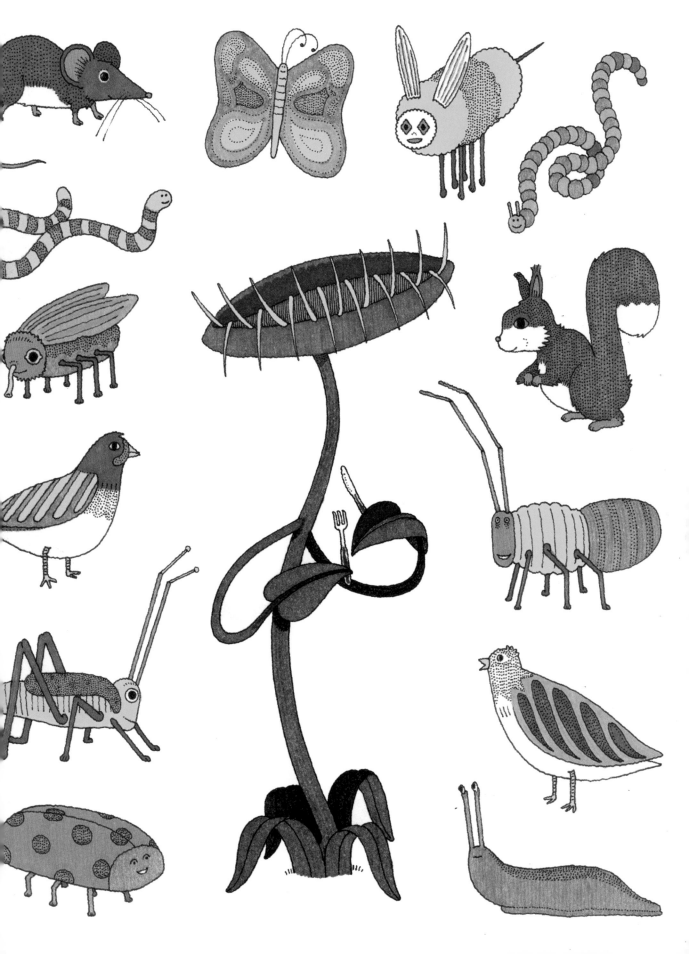

DO IMMORTAL CREATURES EXIST?

WE DON'T KNOW HOW many immortal creatures are eluding discovery or what keys they may hold in extending life, but some organisms do seem to live forever. Recently, scientists discovered a spore that was about 250 million years old within a salt crystal. (Sporulation is a state employed by some bacteria that allows them to hibernate until environmental conditions are favorable for growth, which may occur only after millions of years.) With the utmost care, the scientists were able to extract the spore from the crystal and revive the bacterium. This microorganism had rested as Earth's continents formed from one large landmass, as the dinosaurs rose and fell, as the first lily bloomed, and as modern humans evolved. If this spore had been left undisturbed, yet another 250 million years could have gone by, making this tiny organism, in essence, immortal.

Turritopsi nutricula, a jellyfish that lives in Caribbean waters, is able to regenerate its entire body repeatedly and revert back to an immature state after it has matured, rendering it effectively immortal. Scientists have no idea how the jellyfish completes this remarkable age reversal and why it doesn't do this all the time. It is possible that a change in environment triggers the switch, or it may be solely genetic.

Why can some bacteria and *Turritopsi* survive throughout time? These immortals may hold clues to unraveling the mysteries of our own mortality.

JULIE FREY PhD
Senior Process Engineer
Corning

WRITTEN BY
JESSICA ROTHMAN PhD
Assistant Professor
Hunter College of the City
University of New York

ILLUSTRATED BY
STEVEN GUARNACCIA
www.stevenguarnaccia.com

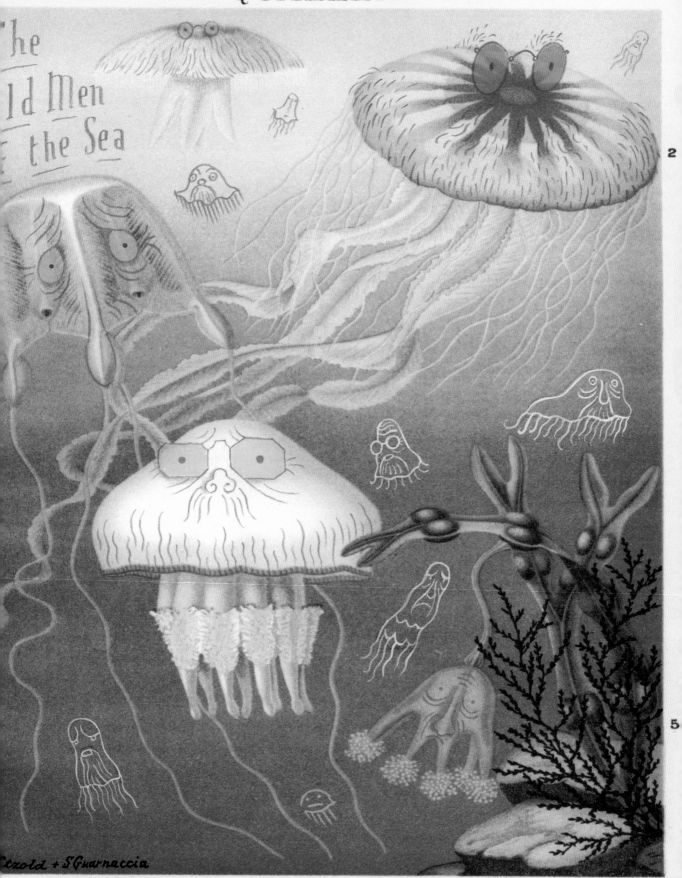

QUALLEN.

The
ld Men
the Sea

2

5

meine Ohrenqualle (Aurelia aurita *L*.). 2. Goldqualle des Mittelmeers (Chrysaora mediterranea *Pér. et Les*.).
meine Beutelqualle (Charybdea marsupialis *Pér. et Les*.). 4. Seelunge, Wurzelqualle (Rhizostoma pulmo *L*.).
5. Pyramidenförmige Becherqualle (Lucernaria pyramidalis *Haeck*.).

WHY DO SOME UNDERWATER ORGANISMS LIGHT UP?

WADE A FEW STEPS into the ocean at night and you may see the water sparkle around you. Your sparkling beach walk is courtesy of bioluminescent dinoflagellates. Once considered magical, bioluminescence, light produced by living organisms through a chemical reaction in which the enzyme luciferase facilitates the combination of oxygen and luciferin, is actually quite common among marine organisms, from bacteria, algae, molluscs, and jellyfish to crustaceans, squid, and fish. It may well be the most common form of communication on the planet, and yet the exact uses of light by many species remain unknown. Loosejaw fish have bioluminescent headlights that they can turn on and off or retract, allowing the fish to communicate in ways that scientists have yet to decipher. Like many other fish, loosejaw fish do not make their own light, but rather store luminescent bacteria in their light organs or photophores.

Theorized uses of bioluminescence include basic life processes such as hunting prey, defending against attack, and attracting a mate. Female anglerfish, for example, have a fishing lure with glowing bacteria hanging over their heads to attract their prey because the prey's usual food is covered with bioluminescent bacteria. Some jellies attract fish prey into their stinging tentacles with glowing red lures that imitate the movement of copepods, the fish's food. In the upper portion of the ocean, fish and invertebrates with photophores on their bellies can obscure their silhouettes from predators that are looking up at them from below by matching the surrounding light. Deep-sea shrimp and squid expel clouds of bioluminescence to confuse predators while they flee. Both males and females of several fish species have species-specific bioluminescent patterns that may play a role in mating rituals.

The dinoflagellates responsible for those glowing beach walks light up when they are bothered by their copepod predators. Several hypotheses have been suggested to explain this behavior. The light may be bright enough to confuse the copepods and stall them long enough for the dinoflagellates to escape. An alternative explanation is that the light attracts the copepods' predators. Still other scientists argue that bioluminescence serves no real purpose for dinoflagellates but is simply a remnant of early evolution in an oxygen-free environment. Their theory is that oxygen produced by newly evolved photosynthesizing plants irritated unaccustomed animals, and the bioluminescent chemical pathway may have evolved as a way to consume all that irritating oxygen.

WRITTEN BY / ILLUSTRATED BY
LINDA D'ANNA PhD
Postdoctoral Fellow
Vancouver Island University

Apak
www.apakstudio.com

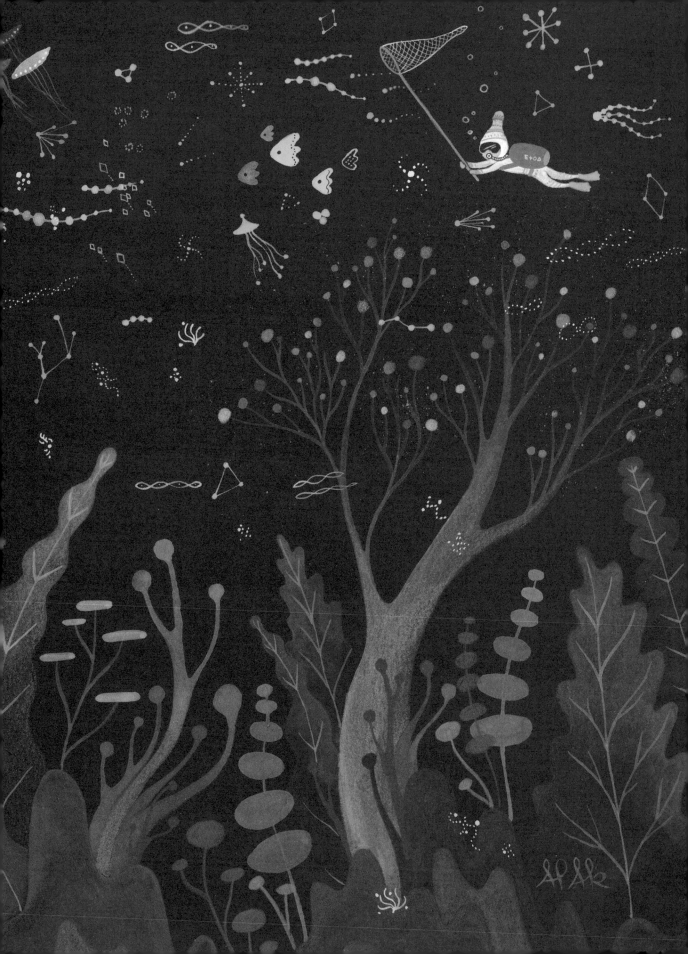

WHY DO WHALES
BEACH THEMSELVES?

HEN ANIMALS TURN up in unusual places, they almost always attract a lot of public attention and interest. A whale or group of whales that has come ashore on a beach can become a sensation and spark round-the-clock rescue attempts. But there is little understanding of what happens right before a stranding episode that actually drives this unusual behavior. Researchers have demonstrated correlations between stranding frequency and periods of climatic warming and changes in ocean currents that shift the abundance and distribution of prey closer to shore. Since variability in the distribution and availability of food dictates patterns in animal migration, nutrient-rich waters moving onshore could bring whales closer to land and increase the probability of stranding. However, while some species will follow inshore migration of their prey, there is often no evidence that stranded whales were feeding at the time of, or just prior to, stranding. Other researchers have proposed that whales use the earth's magnetic field for navigation and they have correlated locations of strandings with geomagnetic lows to suggest that whales come inshore because they have misinterpreted geomagnetic information.

Whales that strand in large groups tend to be social, open-ocean species. Once a critical number of the group head onshore, the rest of the group is likely to follow. Not all highly social species mass strand, but all mass strandings involve social species. Still, explaining why whales come close to shore does not explain why they strand. Perhaps the echolocation signals that whales use to navigate become distorted in shallow water, leaving them trapped and grounded by the outgoing tide. If panicked, some species will swim in a straight line, stranding on any beach in their path. Stranded whales may be victims of poisoning, infectious disease, predation, fisheries operations, or unusual environmental events, such as hurricanes. Noise from human activities in and on the water such as military sonar, seismic activity, shipping traffic, or recreational vehicles may startle whales or disrupt their navigational systems. However, these may be such short-lived episodes that by the time investigation into a stranding has begun, the underlying cause has disappeared. In other cases, strandings during these events may be coincidental. Of all the proposed explanatory theories, one of the least likely is that in times of stress, whales seek safety on land.

WRITTEN BY
LINDA D'ANNA PhD
Post Doctoral Fellow
Vancouver Island University

ILLUSTRATED BY
JEN CORACE
www.jencorace.com

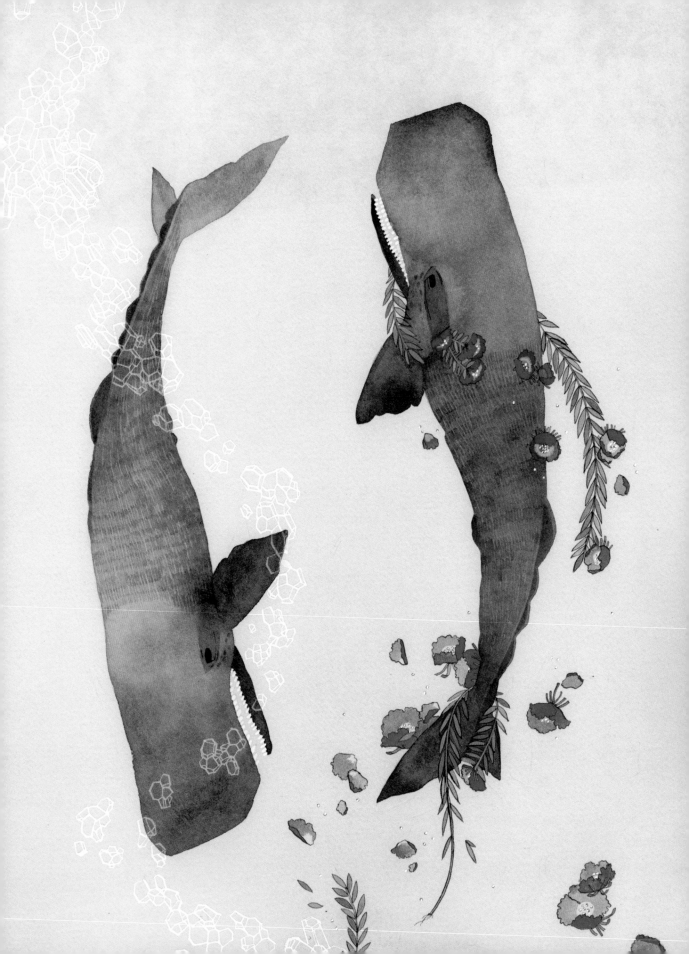

HOW DO MIGRATING ANIMALS
FIND THEIR WAY BACK HOME?

AVIGATING A DIRECT route of hundreds, and sometimes thousands, of miles without maps, sextants, or GPS can be a daunting task, especially if there is no one to ask for directions. Yet countless species of birds and other animals, such as sea turtles, seem to have no trouble doing just that. Innumerable experiments involving everything from blindfolds to attaching magnets to birds' necks have tried to elucidate the exact mechanisms for such precision in migratory patterns. The mechanisms that we have been able to discover are almost as varied as the routes that the animals take to arrive at their destinations.

Some turtles have been found to follow almost indistinguishable traces of soil carried by currents from distant islands to arrive at their feeding sites far away from their hatching locations. Some birds appear to use stars or visual clues for navigation. And yet other birds rely on what appears to be a strong magnetic sense, using Earth's magnetic fields to maintain a straight course for home. The exact mechanism that allows birds to use Earth's magnetic fields is unknown, with some evidence pointing to slightly magnetic compounds in the pigmentation of birds' eyes. In the end, it is likely that the suite of strategies for precise navigation is varied, with different species employing various approaches to find a way home.

WRITTEN BY
ALEXANDER GERSHENSON PhD
Adjunct Professor, SJSU
Principal, EcoShift Consulting

ILLUSTRATED BY
HARRIET RUSSELL
www.harrietrussell.co.uk

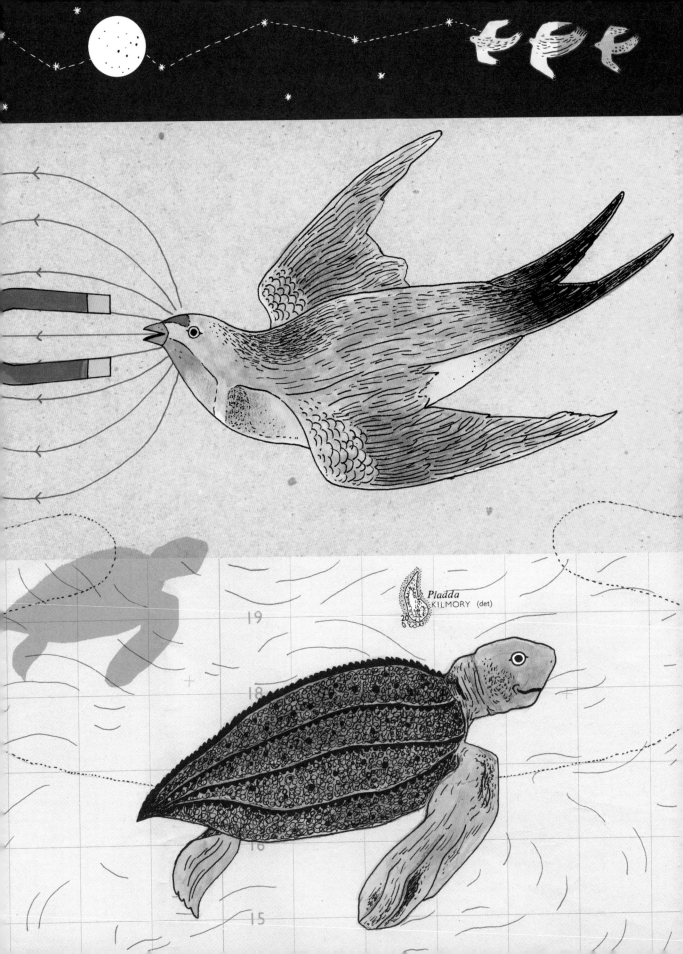

Pladda
KILMORY (det)

WHY DON'T ANIMALS' MUSCLES ATROPHY DURING HIBERNATION?

"MOVE IT OR LOSE IT!" IS a common saying that is certainly true of human muscles. Muscle mass is, to some extent, transitory: It can be gained through a combination of weight-bearing exercise and adequate protein intake, later to be lost through disuse and malnourishment. In fact, many of us have had firsthand experience of extreme muscle deterioration or "atrophy" upon seeing a withered limb after a cast is removed from a broken arm or leg. What's puzzling, then, is why these personal experiences and our own understanding of how our muscles work don't apply to animals in hibernation.

During harsh winter conditions, hibernators such as bats, squirrels, and bears confine themselves to small burrows and dens. They consume few to no calories and restrict all movement (even breathing) drastically for weeks or months, conserving energy for warmer times. Yet in the spring, these animals return to their wily ways with no significant muscle atrophy. Sometimes they are even more wily and fit than before: While overall weight declines during the near starvation of a hibernation or lethargy state, an animal's muscle mass tends to remain constant or even increase.

Why is this? We're not sure. It's possible that regenerative proteins are produced at higher levels when hibernators undergo prolonged motionlessness. Another theory is that periodic stirring or increase of metabolic activity may prevent loss of muscle mass in hibernating animals (much as one would start a parked car weekly to prevent its battery from dying). Either way, research into hibernation is likely to continue, as it could help advance therapies for degenerative conditions and prevent muscular atrophy in humans during space flight.

WRITTEN BY
MARGARET SMITH MA, MSLIS
Physical Sciences Librarian
New York University

ILLUSTRATED BY
ANDREW HOLDER
www.andrewholder.net

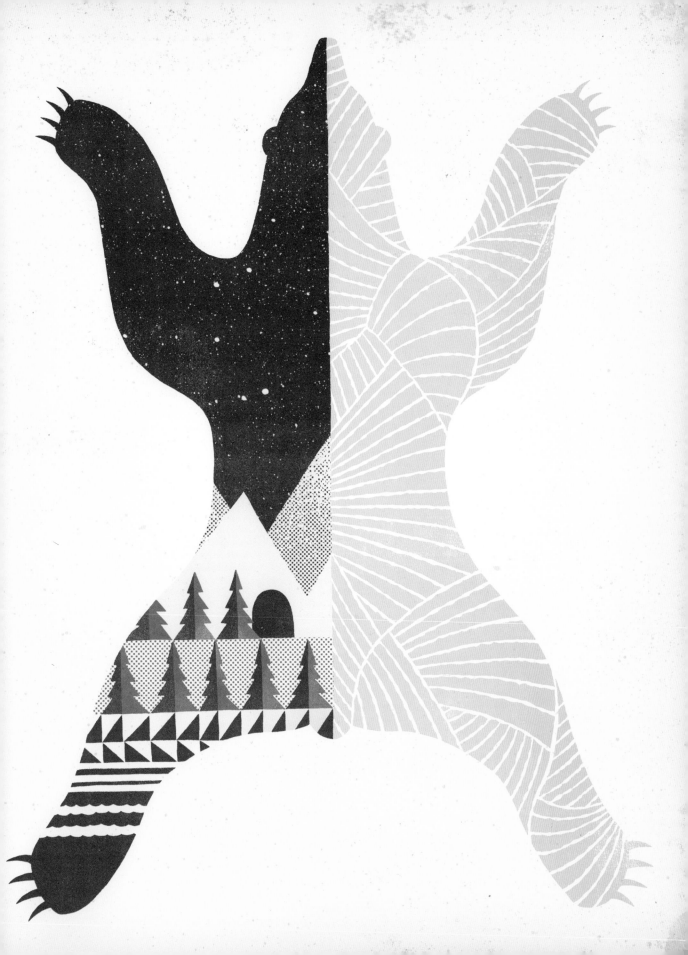

WHY DO WHALES SING?

THE EERILY BEAUTIFUL sound of singing whales has enchanted millions of people since Roger Payne and Scott McVay first discovered whale song in 1967. While all whale species make sounds, only a few, including fin, blue, gray, and right whales, are known to sing. The most striking songs, however, belong to the humpback whale (*Megaptera novaeangliae*), whose song is thought to be the longest and most complex vocalization in the animal kingdom. Humpbacks from different regions sing distinct songs, which usually change slowly over time. However, scientists have recently discovered that if even one or two "foreign" whales (and their songs) are introduced to a pod, the whole group will very quickly learn and sing the new song.

The reasons why whales sing are not yet well understood, however scientists have several hypotheses. Since only male whales sing, and their songs are most often heard near breeding grounds, many scientists theorize that whale song serves as a sexual display, either to attract a mate or to deter other males. Other proposed functions of whale song include greeting, threat and individual identification, echolocation (using reflected sound to find objects), and long-range communication (some low-frequency whale song can be heard by other whales thousands of miles away). However, observations of a given behavior associated with a specific call are very rare, so these theories are, as of yet, inconclusive, and scientists continue to seek answers to this 40-year-old mystery.

WRITTEN BY
DAVID KAPLAN PhD
Postdoctoral Researcher
University of Florida Ecohydrology Laboratory

ILLUSTRATED BY
LISA CONGDON
www.lisacongdon.com

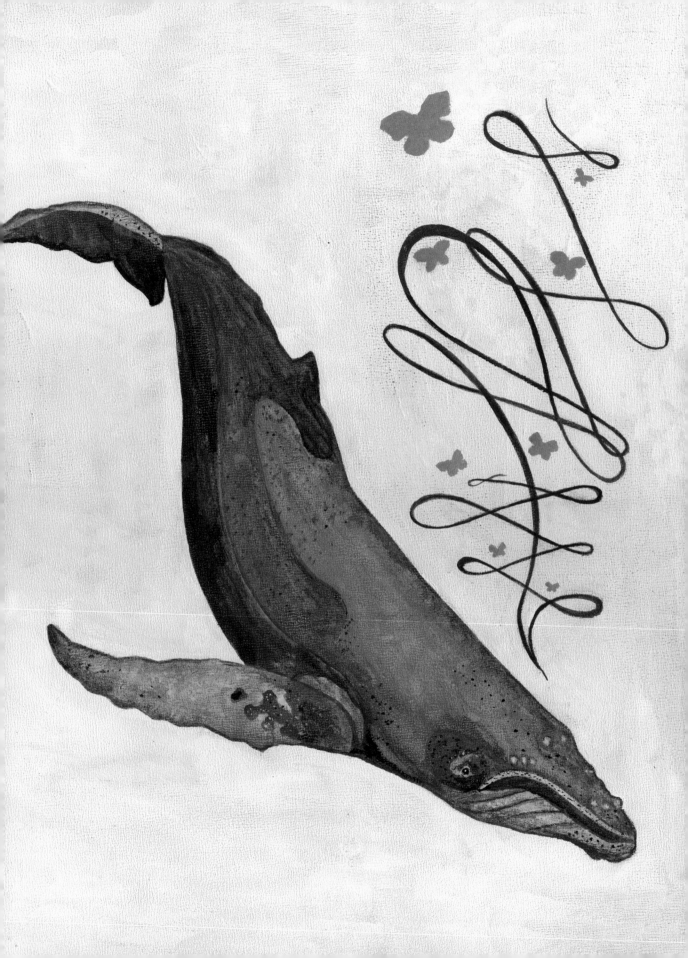

WHAT DOES "CHICKADEE" MEAN TO A CHICKADEE?

THE CHICKADEE, ONE OF our commonest backyard birds, may have one of the most interesting of animal languages. Its simple chickadee call is used as an alarm—and the number of "dees" in the chickadee call gives the size of the predator. The larger the hawk or owl, the fewer number of "dees" in the chickadee call. And even birds of different species, such as the red-breasted nuthatch, will eavesdrop on the chickadees and respond appropriately—being more curious and cautious if the chickadee is giving an alarm call about a smaller, and hence more maneuverable and more dangerous predator. Because chickadees and nuthatches winter in the same area with the same predators, it makes sense for them to be "multi-lingual" and understand exactly what another species is "saying." But do they learn this from each other when young, just as songbirds learn their own song from their own species? How many species' songs are they listening to and responding to? With all of this eavesdropping among species, what chickadees are saying to other species and vice versa may be much more complex than we imagined.

WRITTEN BY
LUCIA JACOBS PhD
Associate Professor
Department of Psychology
University of California at Berkeley

ILLUSTRATED BY
SUSIE GHAHREMANI
www.boygirlparty.com

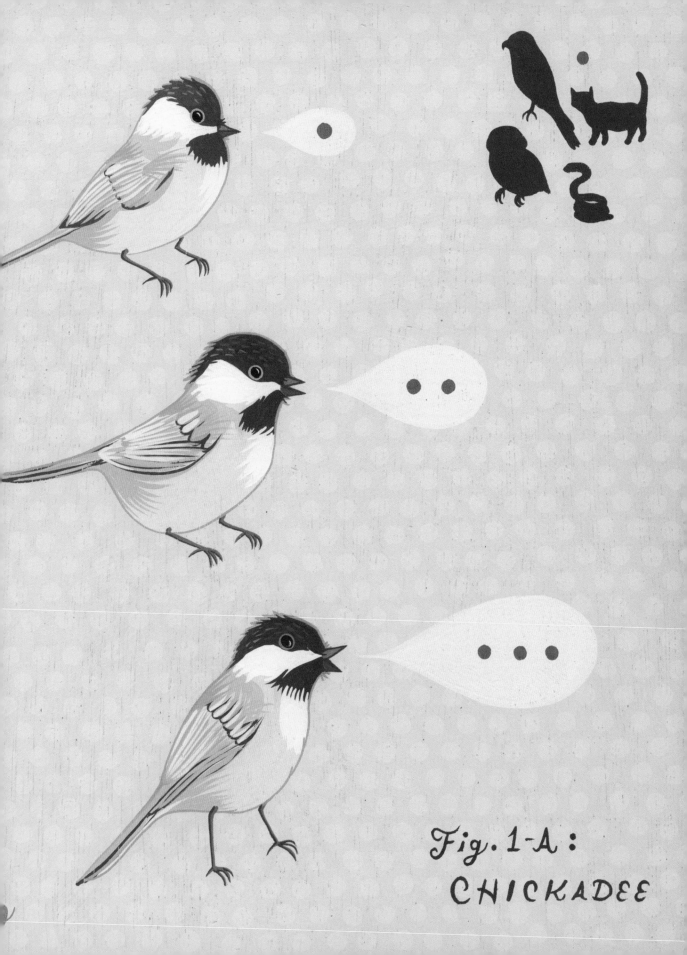

Fig. 1-A: CHICKADEE

WHY DO PIGEONS BOB THEIR HEADS WHEN THEY WALK?

ANY SPECIES OF BIRDS bob their heads when walking, with the pigeon being perhaps most well known for this distinctive behavior. Although it appears that they bob their heads back AND forth, a pigeon actually holds its head still as its body moves forward. Then the pigeon thrusts the head forward as the body is still, creating the illusion of bobbing. This movement is highly synchronized with the pigeon's feet.

Head-bobbing was assessed in a study by Dr. Barrie Frost, who videotaped pigeons on a treadmill. When the pace of the treadmill matched the pigeon's walking, bobbing disappeared.

Dr. Frost inferred that head-bobbing is related to visual processing and stabilization, rather than to movement or balance.

Pigeons have eyes on the sides of their heads, which gives them a wide visual field. They rely less on binocular vision than other animals and have little ability to move their eyes. Thus, head-bobbing may have important functions: The stationary phase may allow pigeons to detect motion in the environment, while the bobbing phase may aid depth perception. Combined with a wide visual field, head-bobbing may help pigeons stay alert for predators like hawks or food opportunities such as humans offering bread crumbs.

WRITTEN BY
MIKEL MARIA DELGADO
Certified Cat Behavior Consultant, Feline Minds
PhD Student, Psychology
University of California, Berkeley

ILLUSTRATED BY
ALEX EBEN MEYER
www.eben.com

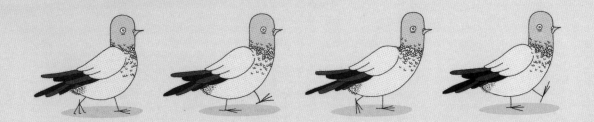
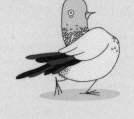
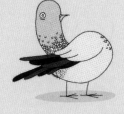
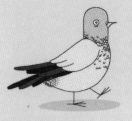
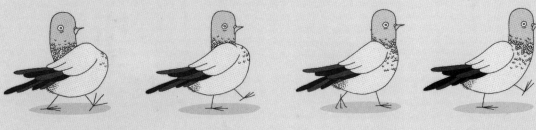
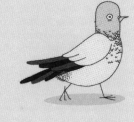
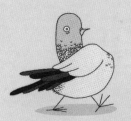
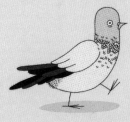

DO SQUIRRELS REMEMBER WHERE THEY BURY THEIR NUTS?

ECAUSE OF THEIR ACUTE sense of smell, it was long thought that squirrels simply sniff out buried nuts. But captive studies found that squirrels create a mental map of their caches and can accurately retrieve them using just this memory. Yet squirrels such as the eastern gray and the fox squirrel may cache over 5,000 nuts each fall— do they remember all these locations? We don't know, though the fact that the gray squirrel's brain actually grows in size during the caching season may show increased memory. On the other hand, recent studies have shown that when one squirrel buries a nut, it is almost impossible for another squirrel to detect it unless it actually watched the nut being buried. Paradoxically, if a human buries a nut at exactly the same depth (about 1 inch), a squirrel has no trouble detecting and pilfering the cache. So this suggests that a squirrel makes caches less detectable by odor in some way that we haven't yet identified— and for this reason, it is critical for each squirrel to have a precise memory for the locations of its buried nuts.

WRITTEN BY
LUCIA JACOBS PhD
Associate Professor
Department of Psychology
University of California at Berkeley

ILLUSTRATED BY
AARON MESHON
www.aaronmeshon.com

WHY DO CATS PURR?

PURRING IS A TACTILE AND auditory signal used by cats in contact with other individuals, including humans and other cats. Although purring is associated with comfort and pleasure, some cats will also purr when they are in distress or pain.

Other animals may produce similar sounds, but actual purring is unique among the *Felidae* family; most cat species purr. Kittens start purring within the first few days of life, modulating their laryngeal muscles during both inhalation and exhalation to create a rumbling sound that appears continuous to the human ear.

Several theories about purring exist— all of which explain why purring may confer some selective advantages. Recent studies reveal that humans are sensitive to differences in the "urgency" of various purrs. Cats may be exploiting human sensitivity to distress sounds, with urgent purrs enhancing or changing the responses of humans around them. Purring may also help kittens maintain or establish a close bond with their mother, as the behavior frequently occurs in both mom and baby during nursing. Purring might even have restorative properties, as cats purr at a frequency known to improve bone density and healing. This may be a way to promote recovery when cats are injured and need to conserve energy.

WRITTEN BY
MIKEL MARIA DELGADO
Certified Cat Behavior Consultant, Feline Minds
Doctoral Student of Psychology
University of California at Berkeley

ILLUSTRATED BY
GEMMA CORRELL
www.gemmacorrell.com

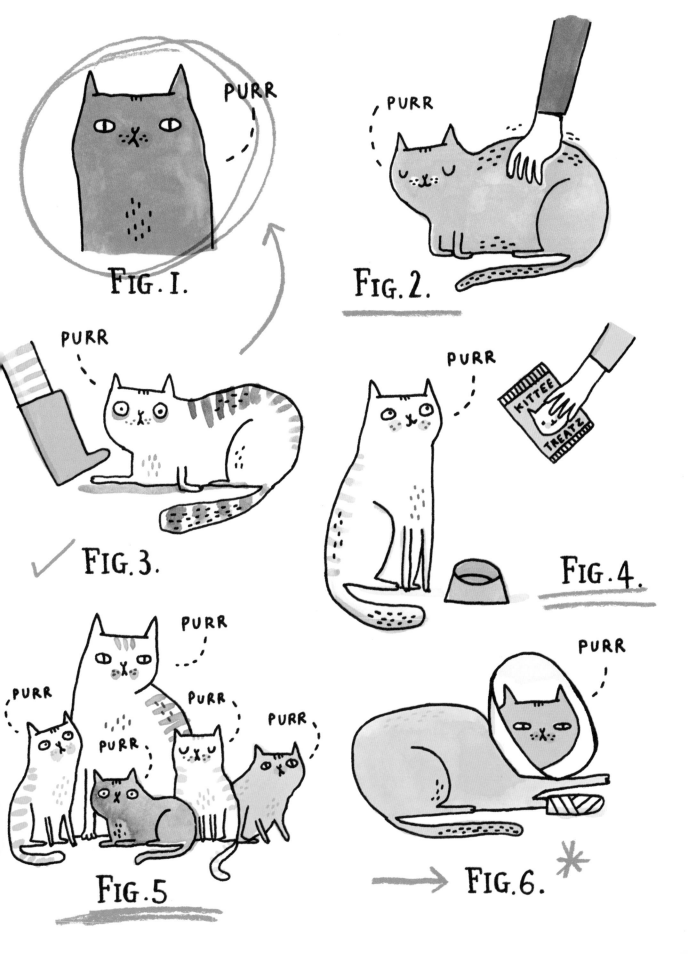

PURR

FIG. 1.

PURR

FIG. 2.

PURR

FIG. 3.

PURR

KITTEE TREATZ

FIG. 4.

PURR

PURR

PURR

PURR

PURR

FIG. 5

PURR

FIG. 6.

WHAT DO HONEYBEES SAY WHEN THEY DANCE?

THE HONEYBEE IS ONE OF the few species that can "talk" about the past using symbolic signals. We are only now beginning to understand what the bees' unspoken language of dance may mean. Our current theory of bee signals goes like this: When a successful bee returns to the hive, her waggle dance gives the direction and distance to the food source, with the distance indicated by the amount of visual flow between the hive and the food. So by following her waggle dance on the vertical "dance floor" of the comb, her nest mates know exactly where to find the new flowers. But a returning honeybee can also edit what she sees on the dance floor. If a bee is attacked by a spider at the new flower patch, she returns to the hive and stops any other dancer from recruiting to this now dangerous site. She butts the dancer with her head while giving a short, specialized buzzing sound, after which the dance stops. So bees not only tell each other what to do, but also what not to do. They also use the waggle dance to "vote" for new potential nest sites to occupy in the future. After a century of study, we're still unraveling new stories about what the bee is saying and what she means—and the only thing that is completely clear is that this tiny animal may speak a much more subtle and nuanced language than we could ever have imagined.

WRITTEN BY
LUCIA JACOBS PhD
Associate Professor
Department of Psychology
University of California at Berkeley

ILLUSTRATED BY
CAITLIN KEEGAN
www.caitlinkeegan.com

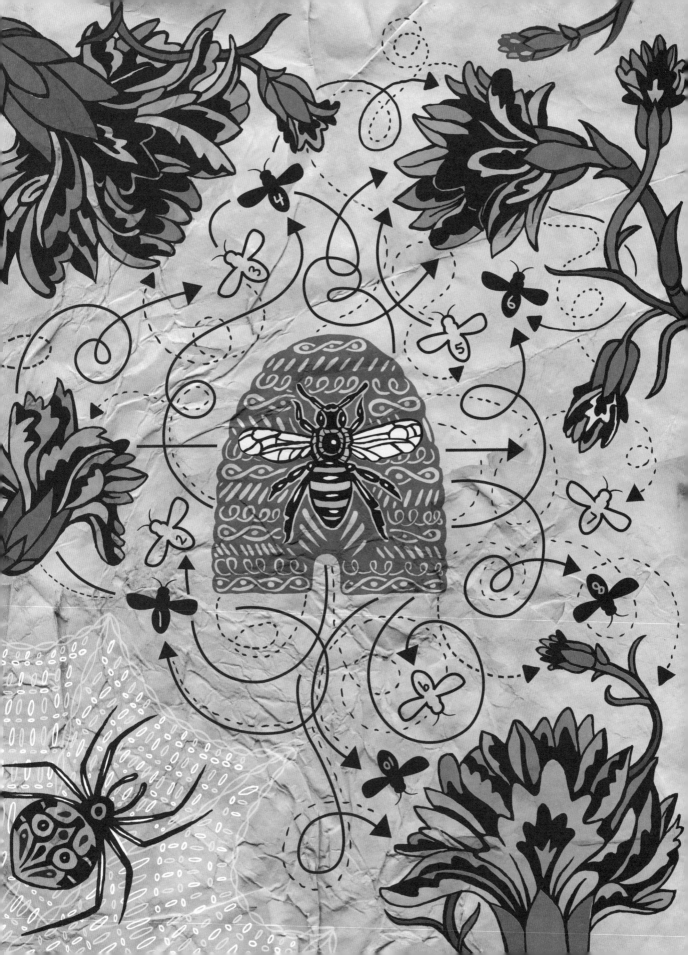

WHY DO HUMANS AND ANTS HAVE SO MUCH IN COMMON?

HEN SCIENTISTS consider behaviors, they have found that although the physical differences are large, humans have more in common with ants than with perhaps any other species.

Like humans, ants have well-defined roles that are designed to keep their society functioning. Consider that ant colonies wage war against other colonies and even enslave other ants. Ants are also the only other species to employ agricultural tactics, as do the leaf cutter "gardener" ants; the "dairymaid" ants that milk aphids for a sweet, honey-like liquid that the aphids produce; and the recently discovered "ranchers" who are hypothesized to raise their insect herds for meat. Furthermore, not only are ant *colonies* considered to have personalities, ranging from docile to aggressive (much like human societies throughout history), but the idea that individuals within colonies have unique personalities is increasingly gaining acceptance.

Why are there so many behavioral parallels between humans and ants? One underlying feature is that both ants and humans rely on social interactions to succeed. Both groups have been incredibly successful because of their high level of social dependency, which allows for extreme specialization of individuals. Neither ants nor humans are the largest, strongest, or fastest animals, but by working cooperatively, both species achieve gains that are far larger than a single individual would experience.

WRITTEN BY
SARA FOX PhD
Biology and Forensic Science Teacher
Cypress Fairbanks Independent School District

ILLUSTRATED BY
JACK HUDSON
www.jack-hudson.com

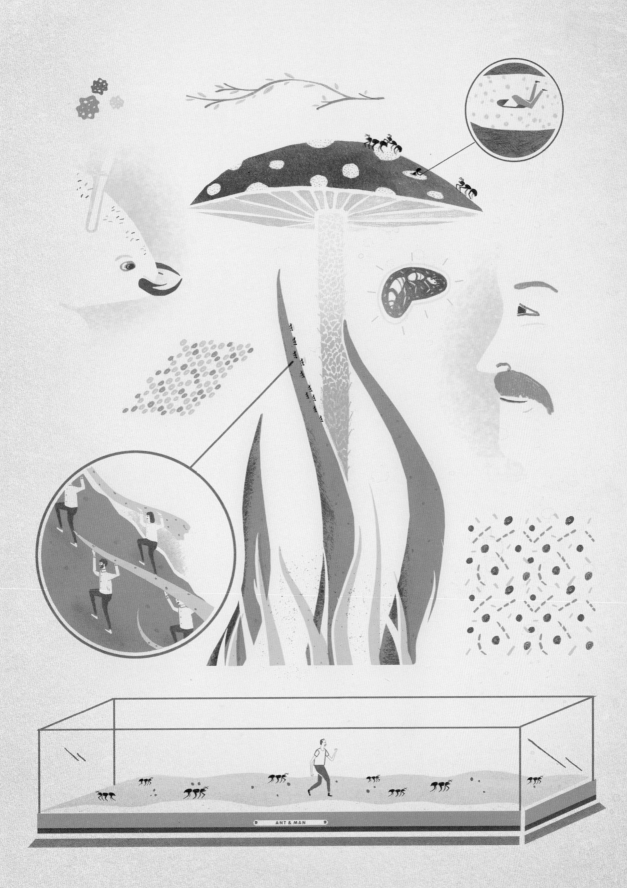

ANT & MAN

HOW MUCH CAN PARASITES CHANGE THE SOCIAL HABITS OF THEIR HOST?

ARASITES CAN DRAMATI-cally change the social behavior of their hosts in some cases. This may happen at the level of group interactions; or it may be a case of affecting a single individual. One of the classic cases of individual modifications that markedly change a host's behavior and social habits occurs in crabs infected with another crustacean parasite, a species of the genus *Sacculina*, an organism related to the barnacles on ships and whales.

In this parasite-host relationship, the parasite radically modifies the host's behavior in order to use the host as a surrogate to protect and produce its own reproductive forms. The parasite enters the crab as a small female larval form known as a *kentrogon* that grows within the crab into a mass of branching forms along the crab's nervous system and other organs throughout the crab's body. Ultimately, the parasite softens the crab's tissues in the area where the crab usually broods its own eggs, and then the female parasite attracts a male of its own species to fertilize the eggs it has produced within this area. The crab nurtures the eggs and grooms and protects the developing egg mass as though it were its own. When the time comes for the developed spawn to disperse, the crab performs behavior typical of a crab releasing its own brood into the environment. The parasite is even capable of causing both behavioral and morphological feminization of a male crab host such that it will act as a brooding female crab nurturing the parasite's eggs and then performing female-like ritual behavior to release the parasite's brood into the environment just as though it were a female crab.

This intriguing example demonstrates there is much more to learn about how parasites affect host behavior. For example, do sexually transmitted parasites affect sexual behaviors of their hosts, and do parasites transmitted through close contact change host spatial proximities? Investigations of the dynamics of host-parasite interactions are fascinating areas for future research.

138

WRITTEN BY
DWIGHT D. BOWMAN MS, PhD
Professor
College of Veterinary Medicine
Cornell Univeristy

ILLUSTRATED BY
TED MCGRATH
www.tedmcgrath.com

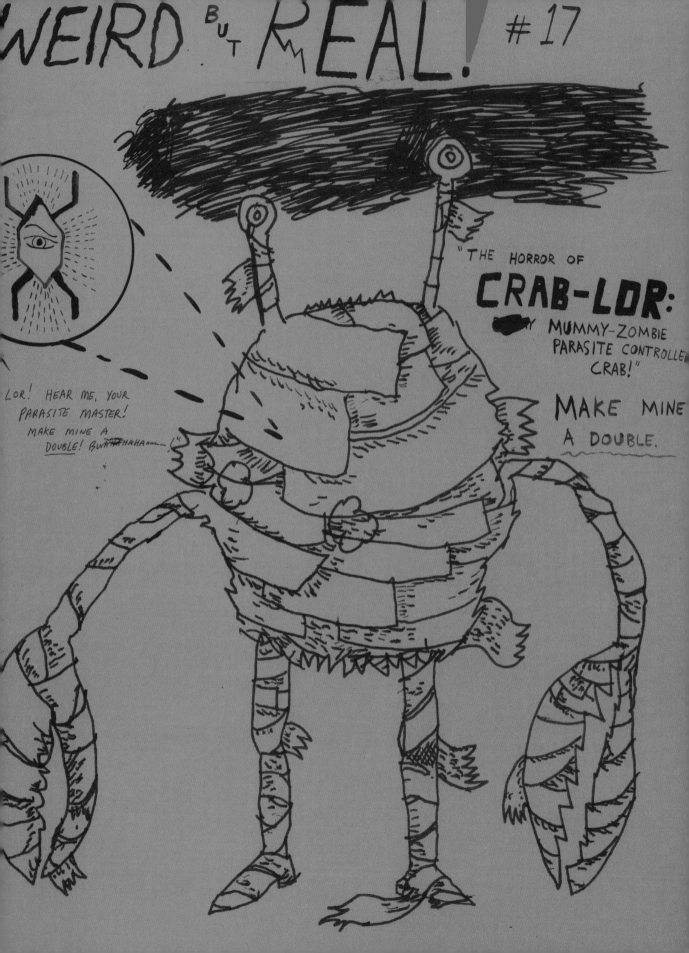

WHERE WILL THE NEXT PANDEMIC COME FROM?

VERY SO OFTEN, A NEW infectious disease slips into the population, circulates quietly for a few weeks or months in a contained geographic area, and then explodes into a global pandemic. Predicting when and where the next pandemic will come from is difficult, but recent outbreaks like swine flu and SARS give us some hints.

We know that most emerging infectious diseases are caused by animal viruses that jump into humans and gain the ability to spread from person to person—HIV entered humans through the African bushmeat trade, Nipah virus moved from fruit bats to pigs to humans, SARS started in bats and was transmitted to humans through wild civet cats sold at market—so the next pandemic will almost surely be traced back to an animal source.

We also know that people are most likely to come into contact with these animal sources through practices like hunting, farming, and selling animals at market and that changing land-use and deforestation also influence the degree to which we interact with animals. Thus, the next pandemic will likely start in a region where humans and animals are in close contact on a regular basis; Southeast Asia is mentioned as a likely point of origin.

Outbreaks of infectious disease are inevitable, and the coming years will surely bring another pandemic. Although we don't know where and when it will happen, we can improve our surveillance of the animal population in the hopes of spotting a new disease before it spreads too far.

WRITTEN BY
JENNIFER GARDY PhD
Leader, Molecular Epidemiology
British Columbia Centre for Disease Control

ILLUSTRATED BY
JAMES ULMER
www.jamesulmer.com

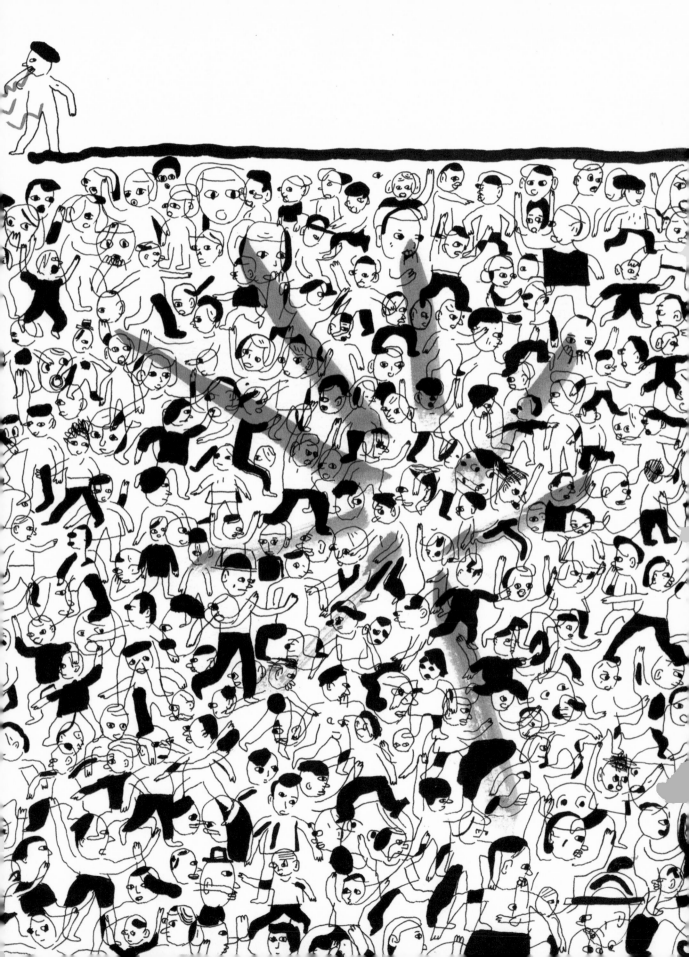

HOW MUCH OF HUMAN BEHAVIOR IS PREDETERMINED?

OW MUCH OF HUMAN behavior is predetermined genetically, that is, fully controlled by genes, not learned? This is the perennial nature versus nurture question. Because human behavior is very complex and different aspects of it may be under different levels of genetic and environmental control, we don't have an answer to the question. For example, a baby loving her mother and an adult loving spicy foods are both examples of behavior, but they are under different levels of genetic control.

When a behavior is under complete genetic control, it is said to be hard-wired—it is acquired quickly, but is rigid and inflexible. For example, spiders eat bugs, but never carrots. If there are no bugs, the spider will starve to death, and no level of experience will ever change that. In contrast, humans are avid learners—they learn all the time, from the womb (literally) to the grave. Furthermore, humans have a protracted period of life dedicated exclusively to learning. It is called "childhood," and, regardless of life expectancy, it occupies 15 to 20 percent of the total life span. No non-primate species has such a long period dedicated to learning. We are born to learn! None of the interesting human behaviors are fully determined genetically, although genes play an important role. Unfortunately, this flexibility of human behavior is not free. We hold people responsible for their actions, and under what circumstances should they and should they not be accountable for what they do? Alas, this is a moral question, and science cannot answer it.

WRITTEN BY
VLADIMIR SLOUTSKY PhD
Professor
The Ohio State University

ILLUSTRATED BY
CATELL RONCA
www.catellronca.co.uk

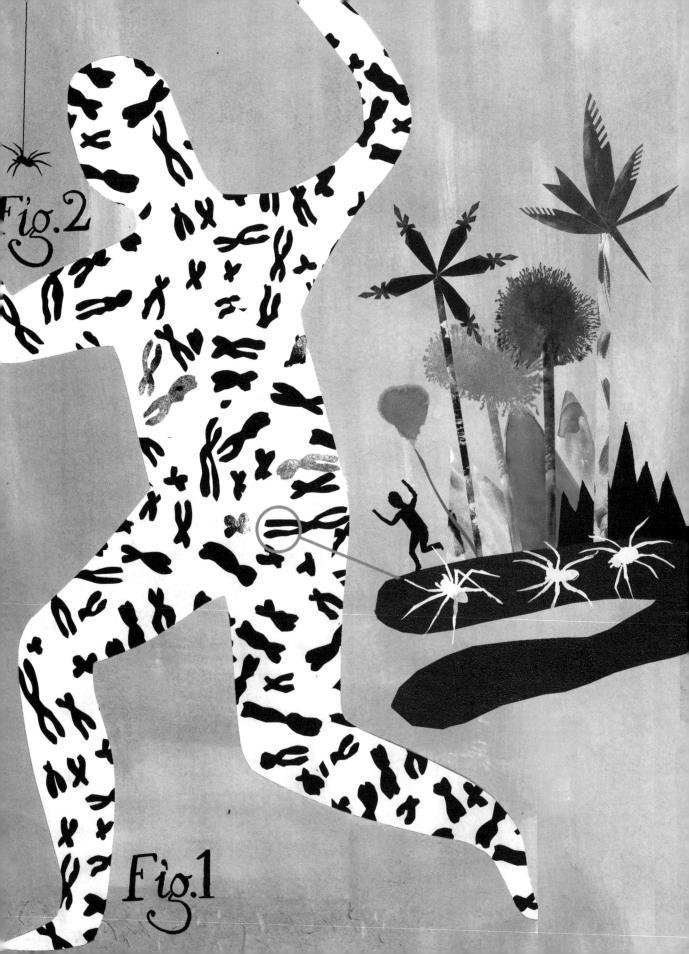

Fig.2

Fig.1

HOW DOES THE BRAIN GIVE RISE TO THE MIND?

WE CAN INVESTIGATE the brain at many different levels, from atoms to molecules to cells to neural networks to brain regions to the whole brain. Yet even as we gain an ever more detailed understanding of the mechanisms at work on these different levels, we still can't connect the dots: How do the inanimate constituents of the brain give rise to the mind?

The place most neuroscientists look to begin addressing this question is at the cellular level, where we find the biological building blocks of the brain, neurons. The activity of these cells is responsible for every thought, sensation, action, and feeling you will ever have. The main activity of neurons is communicating with other neurons, which they do by sending chemical signals across the microscopic spaces between them, known as synapses. An individual neuron may make synaptic connections with up to hundreds of thousands of other cells, and because there are nearly 100 billion neurons in the adult human brain, there are more possible ways to connect all these cells than there are atoms in the universe.

While the mechanisms by which an individual neuron generates and transmits signals are fairly well understood, no one knows how these cellular mechanisms give rise to complex human behaviors and conscious experience. This gap is an example of what is known, in neuroscience, as the "levels problem": how do we get from the level of the cell to the level of human behavior? Historically, attempts to bridge this gap involved digging through the matter of the brain with more and more powerful tools to try to unearth which cells are actually in charge of our thoughts and behaviors. But the closer scientists looked, the more they realized there are no such cells. Rather, the mind arises from the collective activity of billions of neurons networked together. The answer to the levels problem lies within the hum and crackle of all this activity, the mind emerging from the patterns it creates, the sum, in the end, greater than its parts.

MEEHAN CRIST
Resident Writer
Biological Sciences
Columbia University

WRITTEN BY
TIM REQUARTH
PhD Candidate
Neuroscience
Columbia University

ILLUSTRATED BY
JACOB MAGRAW
www.jacobmagraw.com

WHY DO WE FALL FOR OPTICAL ILLUSIONS?

PTICAL ILLUSIONS POINT out the unsettling truth that all of vision is, in a sense, an illusion. For example, it seems as if we see the world in full color, but the resolution of our peripheral vision is so shockingly poor that if you ask a friend to stand in front of you and hold a handful of colored highlighters out to his side while you stare at his nose, you may have the vague sensation of a rainbow in the distance, but you might be surprised to discover that you're unable to name or order any of the colors.

Optical illusions arise from visual stimuli that test the limits of what our visual system has evolved to handle. Often these illusions are the result of assumptions the brain makes as it attempts to interpret visual stimuli into a scene that makes sense. As such, illusions offer important clues about the neurobiology of vision, offering a unique window into neural architecture and its constraints. One striking optical illusion, in which a dot on a page disappears as you slowly move the page away from your face, reveals that a large region of the visual world is, in fact, missing—due to a quirk of human anatomy, we have a sizable blind spot.

And yet, no one noticed this blind spot until its chance discovery in the 17th century, because the brain conveniently fills in the missing information. It is constantly inventing a patch of reality.

In truth, all visual stimuli are ambiguous: A real truck far away and a tiny model of that truck up close can create a projection of the exact same size and shape on the retina. So how do we know what we're seeing? A class of illusions known as "multistable stimuli" shows us that the brain actively deals with ambiguity, interpreting stimuli rather than just sensing it. Multistable stimuli include simple figures such as the well-known image of a vase that can also be perceived as two inward-looking faces. Nothing changes on the page, but these figures flip back and forth in the mind's eye. Strikingly, we never observe both perceptions at once, which indicates that vision is an active process in which the brain struggles to make sense of incoming signals.

Many illusions remain unsolved; we simply don't know why we fall for them. But researchers are trying to understand why they work, because, paradoxically, the limits of our perceptions may provide the key to understanding how we perceive.

146 **MEEHAN CRIST**
Resident Writer
Biological Sciences
Columbia University

WRITTEN BY
TIM REQUARTH
PhD Candidate
Neuroscience
Columbia University

ILLUSTRATED BY
JENNIFER DANIEL
www.httpcolonforwardslashforwardslashwww
dotjenniferdanieldotcom.com

OPTICAL ILLUSIONS

BY JENNIFER DANIEL

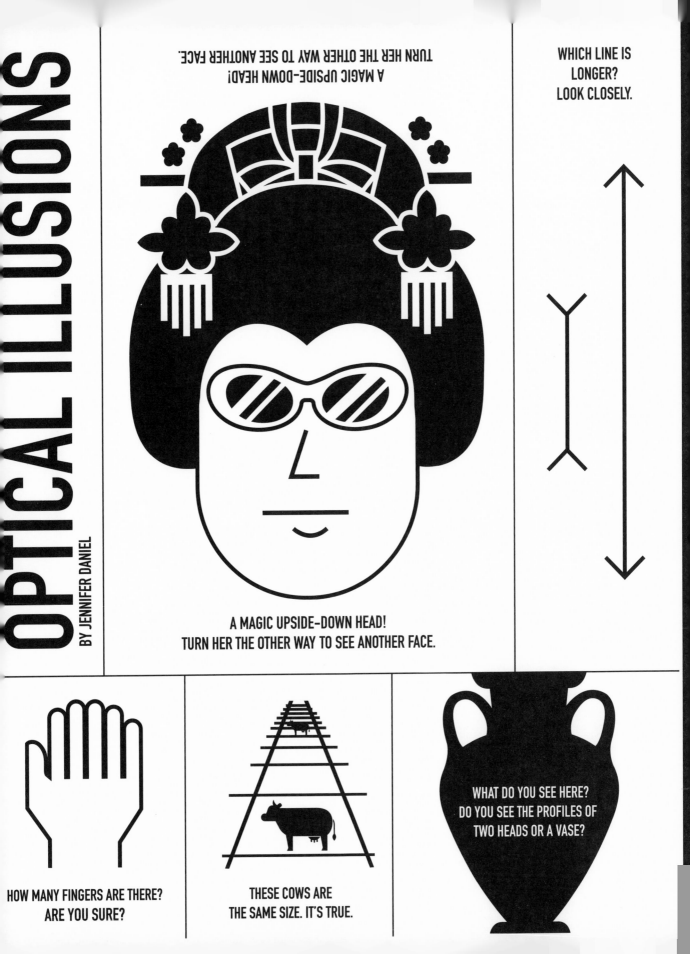

A MAGIC UPSIDE-DOWN HEAD!
TURN HER THE OTHER WAY TO SEE ANOTHER FACE.

A MAGIC UPSIDE-DOWN HEAD!
TURN HER THE OTHER WAY TO SEE ANOTHER FACE.

WHICH LINE IS
LONGER?
LOOK CLOSELY.

HOW MANY FINGERS ARE THERE?
ARE YOU SURE?

THESE COWS ARE
THE SAME SIZE. IT'S TRUE.

WHAT DO YOU SEE HERE?
DO YOU SEE THE PROFILES OF
TWO HEADS OR A VASE?

HOW FLEXIBLE IS THE HUMAN BRAIN?

U P UNTIL RECENTLY, IT was believed that once the human brain finishes developing during childhood, its architecture is fixed. As you age (so the story went), cells begin to die off, connections deteriorate, and eventually entire brain regions begin to falter with little hope of regeneration or repair. But then scientists discovered that the brain is much more flexible than previously thought. Neuroscientists term this extraordinary property of the brain "plasticity."

The idea of plasticity is not new. As early as the late 1800s, Sigmund Freud and William James theorized that physical changes in the brain might underlie learning and memory. But it was not until the 1960s and 1970s that researchers began to discover how extraordinary brain plasticity could be. Neuroscientist Paul Bach-y-Rita, one of the first to explore plasticity, designed an ingenious contraption to help blind people see. A blind subject would sit in a dentist's chair covered with a grid of electrodes that could stimulate the subject's back; this grid was connected to a camera such that the images it captured evoked different patterns of electrode activity on the subject's back (just as pixels stimulate the eye). Remarkably, after a bit of training, the subjects could recognize objects and people in the lab—they could tell whether a researcher was wearing glasses or had her hair up, and could even recognize a picture of the era's most famous fashion model, Twiggy. They experienced the stimuli as coming from the space out in front of them, as if it were visual and not tactile. In a sense, these subjects learned to see with their skin. Experiments like these began to convince scientists that the brain was not as hardwired as once thought.

Plasticity refers to a wide range of ways in which the brain can change, from the cellular level to the level of functional maps in the hills and valleys of the cortex. As recently as the late 1990s, researchers proved that new neurons appear in the adult human brain, challenging long-held assumptions about learning, memory, aging, and the whole architecture of the self. How extensive is the brain's ability to change? How might we harness this power to help the brain heal after illness or injury? Could a deeper understanding of plasticity allow us to enhance normal brain function? The science of plasticity is still in its infancy, but its implications are already revolutionizing the way we think about the brain.

MEEHAN CRIST
Resident Writer
Biological Sciences
Columbia University

WRITTEN BY
TIM REQUARTH
PhD Candidate
Neuroscience
Columbia University

ILLUSTRATED BY
MATT LEINES
www.mattleines.com

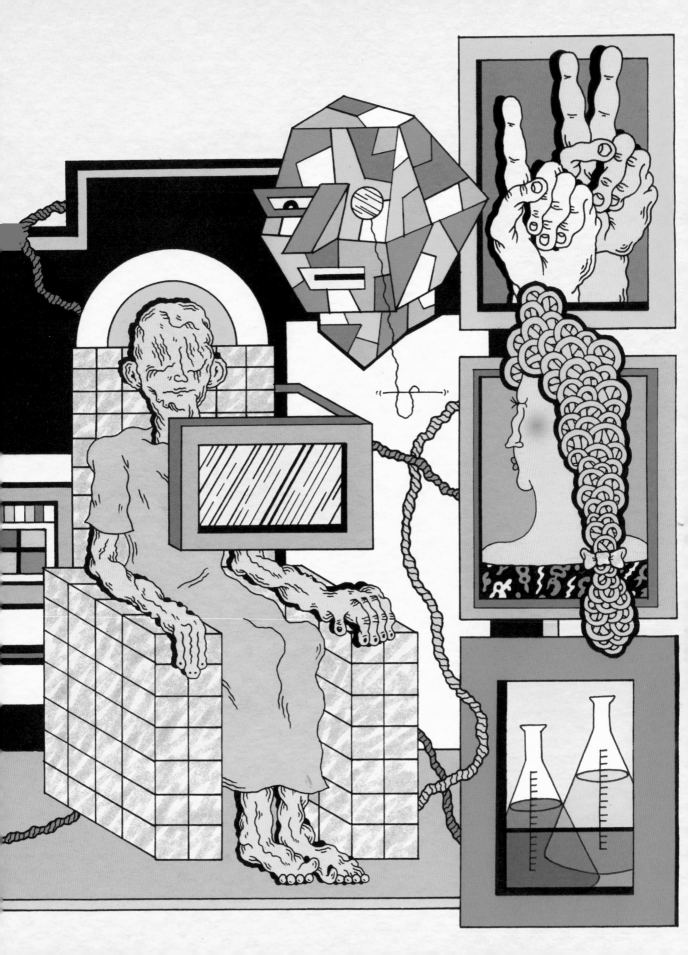

WHY ARE HUMANS AND CHIMPS SO DIFFERENT IF THEY HAVE NEARLY IDENTICAL DNA?

THE GENOME OF ANY ORGAN-ism contains the genes for all the proteins any cell in the organism can make. But genomes are not made up of genes alone. Next to each gene is a region of non-protein-coding DNA which regulates the expression of that gene. Production of the protein for which the gene codes can be turned up or down, like the volume on a radio. The regulatory region is the volume knob for that particular gene. In multicellular organisms, every cell contains the entire genome, though any given cell uses only a fraction of the proteins it knows how to make. Some of the proteins necessary in a liver cell are unnecessary in a neuron. In fact, they may be harmful. To avoid this, each cell determines its complement of proteins by setting the volume controls on genes accordingly.

The genomes of humans and chimpanzees are 95 percent identical, but the protein-coding genes in the two genomes are more than 99 percent identical. In other words, humans and chimpanzees have more or less the same genes. What differences there are between the two genomes are found in the regulatory regions. Therefore, the differences between humans and chimpanzees arise from the differences in when, where, and how much various genes are expressed during the development of human and chimpanzee embryos. We know very little about patterns of gene expression during development of human embryos, and nothing about which genes are responsible for the differences between humans and chimpanzees. Nor do we know when during development or in which cells of the embryo the differences occur. In essence, understanding why humans and chimpanzees are different requires understanding how the genome controls embryo development.

WRITTEN BY
ROMAN SLOUTSKY
PhD Candidate
Division of Biology and Biomedical Sciences
Washington University in St. Louis

ILLUSTRATED BY
MATT FORSYTHE
www.comingupforair.net

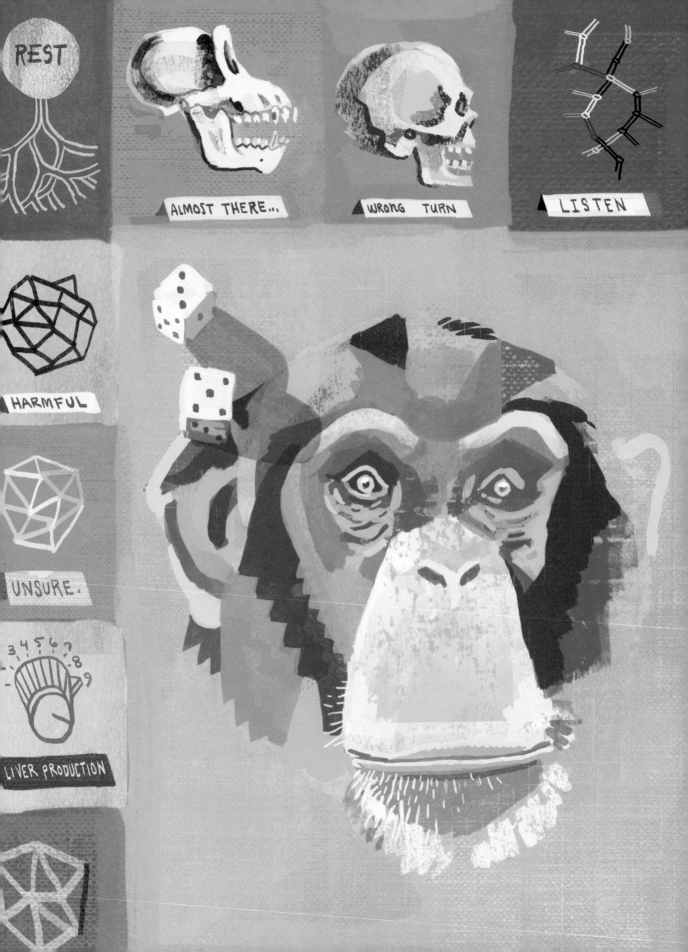

WHY DO HUMANS HAVE SO MUCH GENOME "JUNK"?

DEOXYRIBONUCLEIC ACID is an elegant molecule, a long, twisted ladder with rungs composed of four types of simple units called bases. The sequence in which these bases are strung together carries information, much like the sequence of letters in a word (and in turn, words in a sentence). With DNA, the information carried is the blueprint for an organism's development and functioning. For instance, DNA codes for the production of proteins, which not only form the structural components of every cell in the body, but also comprise the enzymes that catalyze the chemical reactions necessary for life.

Although the DNA blueprint is best known for this protein-coding role, only a tiny fraction of our genome serves this purpose. The remaining non-coding portion—estimated to be as much as 98 percent—is often saddled with the unfortunate nickname "junk DNA." For some types of non-coding DNA, like those resulting from gene duplications over millennia of evolution, this moniker may be deserved. For instance, one experiment actually removed 0.1 percent of the mouse genome with no detectable effect, indicating that the deleted DNA lacked biological function.

Nevertheless, we are gradually discovering that much of our non-coding DNA is, in fact, necessary to our survival. One line of evidence that strongly supports this conclusion is studies that compare the genomes of species that diverged long ago, hunting for regions of DNA that are conserved over time despite the tendency of DNA to steadily and randomly accumulate mutations along its length. Scientists believe that where particular segments of DNA are conserved over millions of years of potential mutation events, these segments must perform some essential function. The implication is that whenever mutations to these segments occurred, the organism bearing them did not survive to reproduce and pass them along. We might expect segments of DNA labeled "junk" not to fall into this category: If these non-coding regions really are junk, they should be able to mutate freely without detriment to an organism's survival. However, studies have shown that much of the DNA conserved between species is actually of the non-coding variety. For instance, 80 percent of the DNA conserved between mice and humans, two species that have not shared a common ancestor for tens of millions of years (and thus have accumulated a vast number of mutations between their genomes), does not code for proteins.

So, what exactly are these regions that are not coding for proteins, the so-called junk, doing? Transposable elements, the most prevalent type of non-coding DNA, are still somewhat of a mystery to researchers. We have discovered that these intriguing bits of DNA can literally jump from one part of the genome into another, imparting benefit (genetic diversity) or detriment (genetic defect). They can be co-opted, put to work regulating when, where, and how much DNA will be transcribed and translated into protein. But more questions than answers remain. We are just beginning to uncover the extent of their contributions to genomic function and evolution.

And that's just one type of non-coding DNA. Junk? Hardly.

WRITTEN BY
KATHERINE PHILPOTT MS, JD
Independent Forensic Consultant

ILLUSTRATED BY
MATT LAMOTHE
www.also-online.com

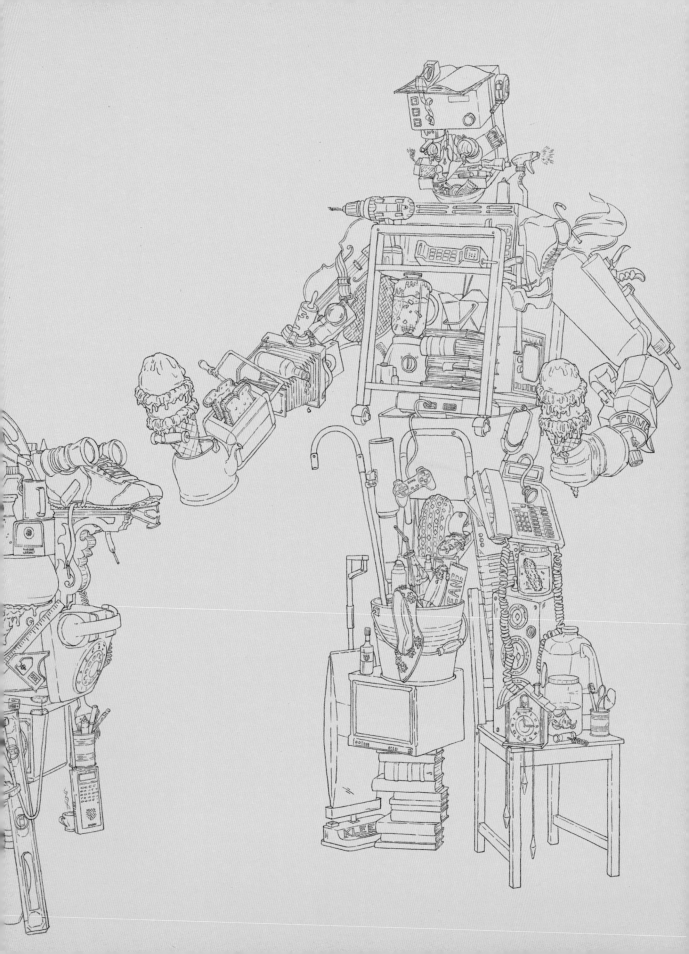

HOW CAN A MATURE CELL BE "REBORN"?

THE HUMAN BODY IS COMposed of trillions of cells and each cell is one of hundreds of different types. These cells all originally come from one fertilized egg cell, subsequently multiply and narrow their cell fate until they become a specific mature cell, and stop multiplying. One exception are adult stem cells, which are held in a partially mature state and retain the ability to multiply to replace dying cells. Although some adult stem cells can mature into several different cell types, each adult stem cell is limited to one or a few related cell types usually found in the same tissue in which the stem cell resides. This is in contrast to embryonic stem cells which can become all cells of the mature organism.

Recently, techniques for making a mature cell become like an embryonic stem cell have been discovered. These "deprogrammed" cells can multiply and mature into any cell in the body. Several diseases, and many of the negative effects of aging, result in a loss of cells' ability to multiply and renew themselves. So these deprogrammed cells might be able to be used to renew aging organs and tissues and might even be used to make "lab grown" replacement organs. Since they would be from the recipient's own body, tissue or organ rejection would not be a problem.

Unfortunately, most current methods for deprogramming cells rely on inserting extra copies of human genes into cells. This process carries a significant risk of making cells cancerous. It is reasonable to think that we may find efficient, safer methods in the near future.

WRITTEN BY
KEITH WEISER PhD
Postdoctoral Researcher
University of Hawaii

ILLUSTRATED BY
BEN K. VOSS
www.benkvoss.com

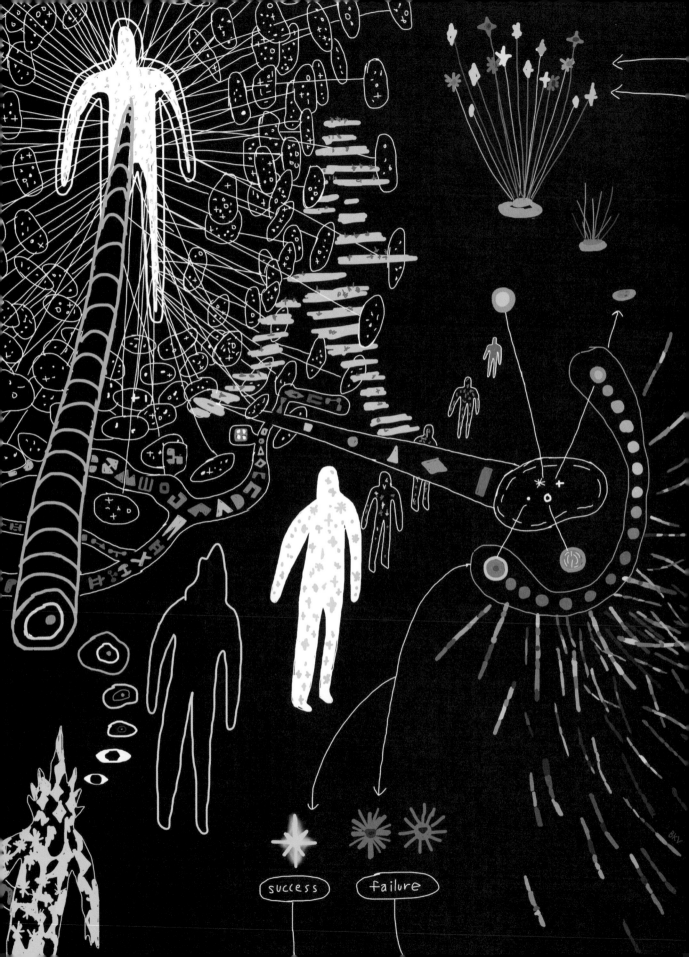

success failure

HOW DO CELLS TALK TO EACH OTHER?

 ELLULAR CONVERSATIONS are felt, not heard. Information flows from one cell to another through "cell signaling pathways" that require signals, receptors, and responders. As a *signal* is passed between one cell and another, it is received by a *receptor* located on the cell membrane. This triggers the *responder* to secrete new signals, change cell shape or movement, or even die. Cells often kill their anti-social or loquacious neighbors, as they can lead to diseases such as cancer.

Surprisingly, there are only 17 major cell signaling pathways in animals. These same pathways somehow choreograph all the different ways embryos develop into distinct species with diverse body types. Furthermore, most cell signaling pathways work similarly in plants, fungi, and even in unicellular organisms. How the same means can work to achieve such different ends remains mysterious.

Three contested properties could help resolve the paradox. First, the same signaling pathway often elicits totally different responses depending on the strength of the signal (like a parent saying no, NO, or NO! to her child). Second, responders might be able to read combinatorial codes written by two or more co-stimulated receptors. Finally, crosstalk between signaling pathways could fine-tune responses. For instance, some signals degrade signals from other pathways—literally eating their words.

WRITTEN BY
JUSTIN CASSIDY
PhD Candidate
Northwestern University
University of Chicago

ILLUSTRATED BY
CHRIS KYUNG
www.infinitearticle.com

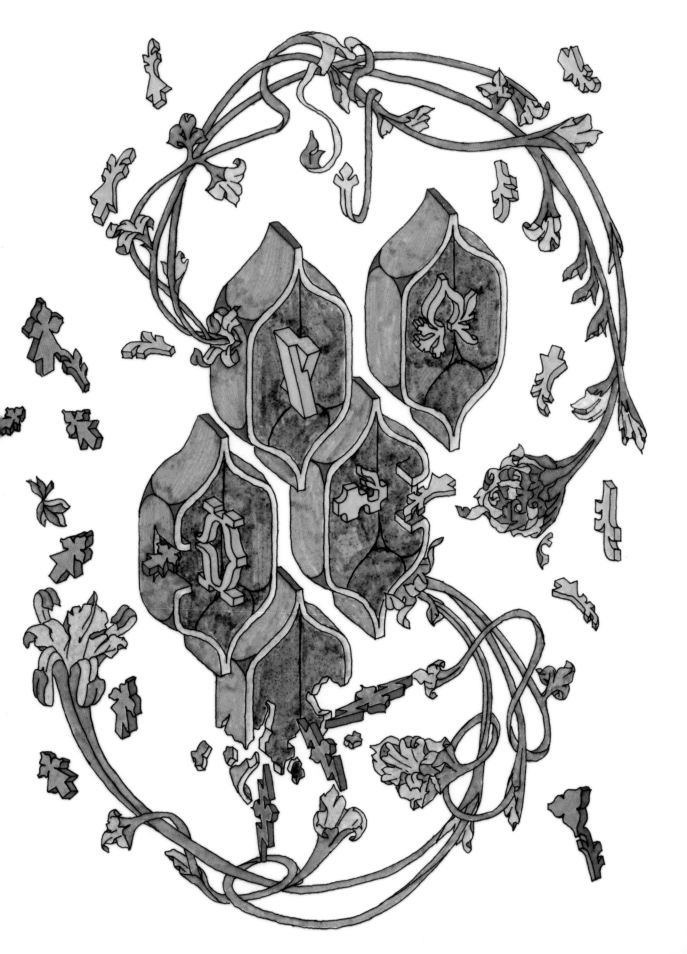

HOW CAN CANCER BE SUCH A BIOLOGICALLY UNLIKELY EVENT, AND STILL BE SO COMMON?

FULLY GROWN, OBVIOUS CANcer is actually very unlikely. Many rare events have to come together in a chain of bad luck in order for a tumor to form, grow, and survive all the obstacles in its path. The first such obstacle is the guardian of genetic fidelity: A set of genes that proofreads the freshly replicated DNA of new cells. If it finds an error in the genetic code, the guardian commands the mutated cell to commit suicide, or "apoptosis." At any given time, each of us has multiple mutated cells. But none of these mutations can cause cancer unless the right kind of mutation takes place, one that enables the cell to escape the watchful eye of the "genome guardian." If it does, this cell can go on to become the single ancestor of an entire tumor.

The offspring of this mutant parent don't fall far from the tree: They too can fly under the genome guardian's radar, and can therefore avoid being sentenced to suicide. Once they do, they go on accumulating more and more mutations in so-called multi-step carcinogenesis. Some of these mutations may be lethal, so the tumor will die at an early stage and we will never know it existed. Other mutations may be beneficial for the tumor: They can help it survive and evade new dangers. The most important danger to the tumor is the body's immune system, which is a very effective surveillance system. If it weren't, we'd all have multiple cancers many times over. But if the body's immune system is weakened, say, by age or by illness, like AIDS, it can miss these upstart mutant cells. Once they escape the immune system, the tumor cells have to get even more creative. They have to develop mutations that will allow them to survive in conditions that would be fatal for normal cells: little to no oxygen or nutrients, and restricted space to grow. Some mutations can help the cancerous cells get around these obstacles by stimulating the growth of new blood vessels to bring oxygen-rich blood right to them. Other tricks include invading surrounding tissues or sneaking into blood vessels, which become highways: Now the cancerous cells can go wherever they want. But not all cancerous cells are this adept. Some of the tumor's cells will produce offspring ("subclones") that are not effective at beating the odds, and they will die off without replicating. In the end, the tumors become enriched for the most hardy and sneaky subclones—this is called tumor progression.

Given these obstacles, it's incredible that cancer ever happens at all. And considering the fact that cancer cells are the sneakiest, cleverest, and most tenacious mutants of many, it's no wonder it's proving so tough to cure.

WRITTEN BY
OLGA IOFFE MD
Professor
University of Maryland School of Medicine

ILLUSTRATED BY
DAVID HEATLEY
www.davidheatley.com

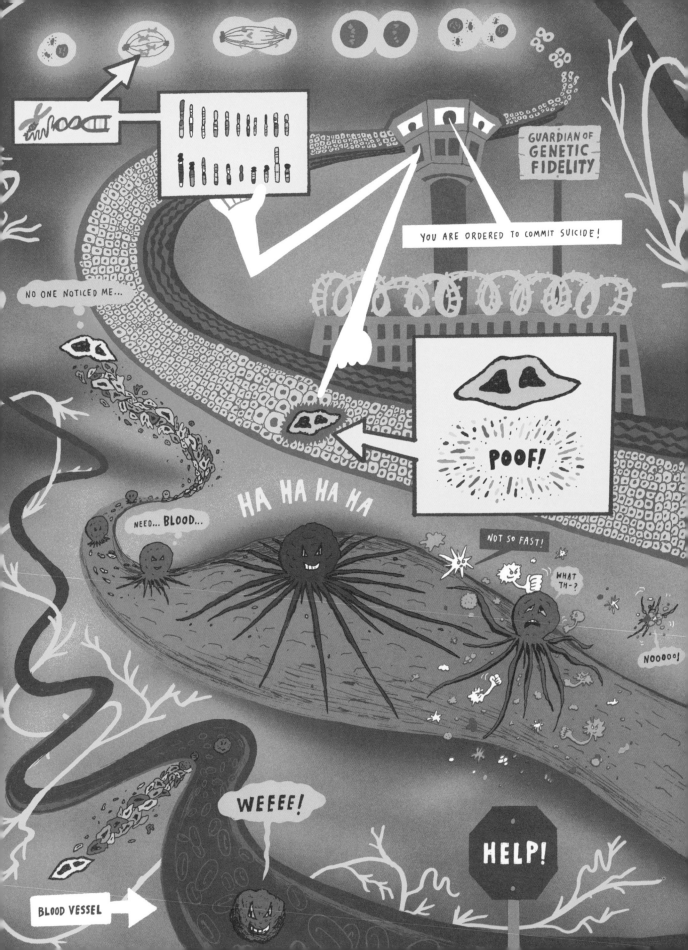

ARE NANOMATERIALS DANGEROUS?

 NANOPARTICLE IS A particle that is between 1 and 100 nanometers in size (almost 100,000 times smaller than the width of a human hair) in one or more dimensions. For centuries in Murano, Italy, artisans have crafted vivid red glass that owes its color to infusions of highly reactive gold nanoparticles. More recently, nanoparticles of silver (known to have antimicrobial properties) have been infused in common, household items such as air-purifiers, socks, washing machines, food storage boxes, computer mice, and more. Nanoscale molecules have great potential for use in reduced-calorie food additives, hazardous gas sensors, stronger and more durable paper, biomedical devices, and cell-specific drug delivery.

The types and degrees of risks associated with nanomaterials are contentious issues, though. For example, while there is no recorded evidence of harm to humans or the environment from nanogold-infused Murano glass, carbon nanotubes (which could potentially reduce the cost and scale of electronics)

are physically similar to asbestos, and are being examined to determine whether additional safety measures need to be taken by workers using them. Will widespread use of products containing nanoparticles lead to their building up in the environment or in people? If so, will this buildup have harmful or benign results? Will common usage of nanosilver antimicrobials lead to bacterial resistance?

There are also questions about how to assess the safety of nanomaterials. Many tests to determine risk are being done in controlled and isolated lab experiments using biological materials. While some scientists believe these tests are adequate to predict how substances will affect animals and humans, others question this assumption. Some, such as the International Organization for Standardization, argue that we should treat each item containing nanoparticles as unique and create specific safety procedures on a case-by-case basis, while others advocate for the development of stringent blanket regulations.

WRITTEN BY
KIYOMI D. DEARDS MS, LIS
Assistant Professor
University of Nebraska-Lincoln

ILLUSTRATED BY
NEIL FARBER & MICHAEL DUMONTIER
personalmessageblog.blogspot.com

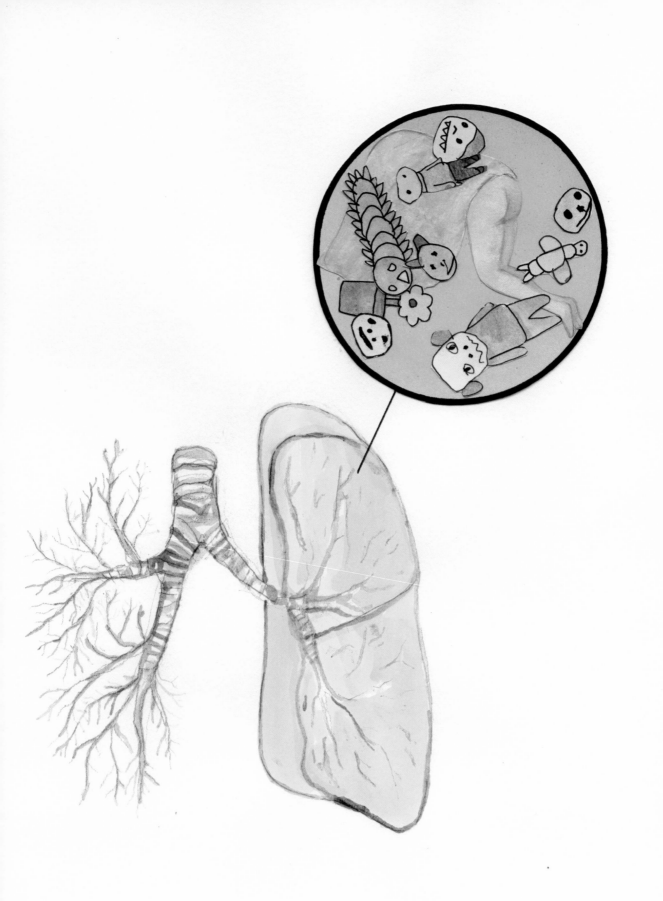

SCIENTISTS

ARTISTS

INDEX

ACKNOWLEDGMENTS

This book was a huge collaboration, so we have quite a few people to thank for helping us put it together.

Our editor Bridget Watson Payne and art director Brooke Johnson for helping us through the book making process with helpful feedback and enthusiastic encouragement.

The patient and thorough copy editors, and the rest of the hardworking Chronicle team who made this a seamless and enjoyable endeavor.

Meg Smith, our official science coordinator, who recruited scores of scientists, helped fact-check, and wrote many follow up emails (as well as writing her three entries).

Jessica Rothman, who aside from being Julia's sister, helped us find all the scientists who wrote about anthropology, while away in Uganda hanging out with gorillas.

Victoria Keener, our other major scientist procurer, who also ended up writing three paragraphs for the book even though she lives in Hawai'i and should have probably been sunbathing.

Tim Requarth & Meehan Crist, who swooped in at the last minute and wrote the final three mysteries about the human mind.

The following scientists who generously donated their time by writing three entries: Alexander Gershenson (who protected Jenny from Rodyka when they were in kindergarten, and is now saving the world by helping businesses lower their carbon footprint), Lucia Jacobs (who provided deep insights into the psychology of some very small creatures), Brett Marroquín (who braved writing about topics of dreams, depression and homosexuality while getting a PhD at Yale) and Brian Yanny (who was able to fit in essays about black holes, big bangs, and the origin of stars while colliding particles at Fermi Lab).

Thanks to the following people for sharing with us the names of their friends/acquaintances and family members who ended up contributing to the book: Becky Aldrich, Ana Benaroya, Hannah Berman, Jason Cassidy, Bess Callard, Paul Citrin, Abi Cohen, Lisa Congdon, Siobhan Dooley, Maria Dimou, Eugenia Etkina, Ben Finer, Lauren Nassef, Brendan Picker, Blair Richardson, Marylin Schweitzer, Mikhail Semenov, Katya Semyonova, Jill Vogel, Vicky Volvovski, Hillary Wiedemann, Dave Zackin, and Jaime Zollars.

Thanks to our families for helping to brainstorm ideas and questions to pose to scientists, and also feeding us dinners. And more specifically to Jenny's mom for suggesting to focus the book on the unsolved/unproven mysteries of science.

Thanks to Google.

And of course, thanks to all the other scientists and artists who participated in the book who have not been mentioned so far.